W9-CEB-994

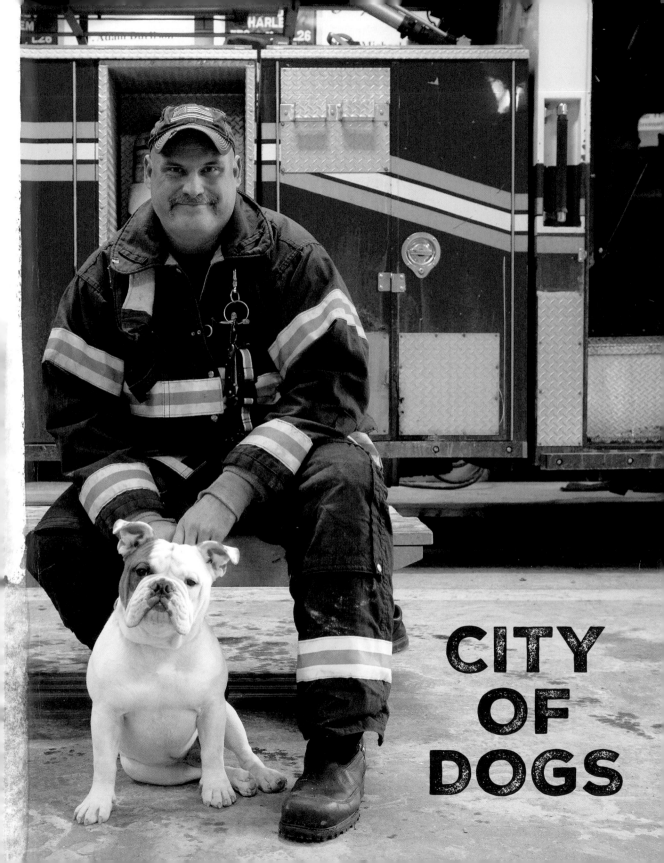

CITY
OF
DOGS

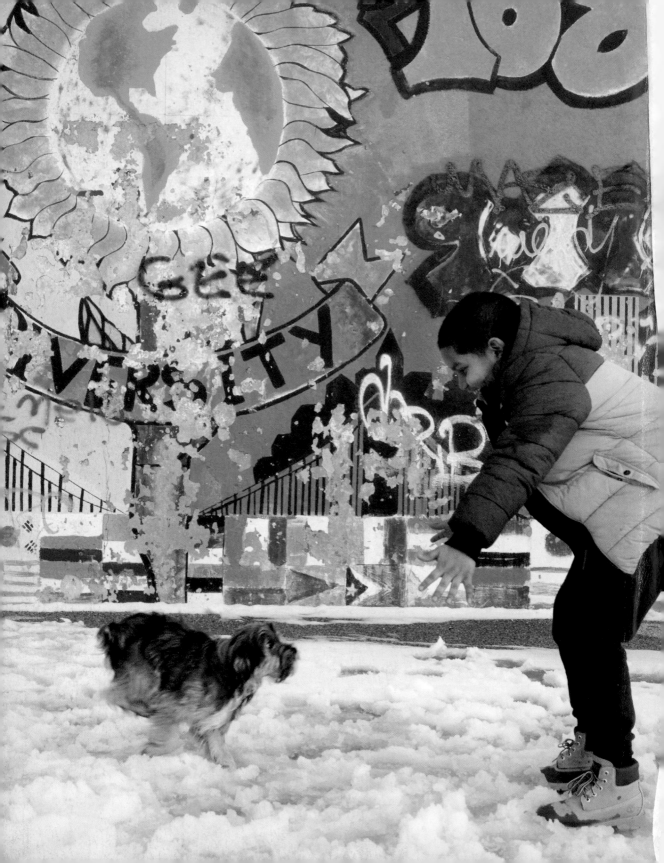

CITY OF DOGS

NEW YORK DOGS, THEIR NEIGHBORHOODS, AND THE PEOPLE WHO LOVE THEM

STORIES BY KEN FOSTER

PHOTOS BY TRAER SCOTT

AVERY
an imprint of Penguin Random House
New York

AVERY

an imprint of Penguin Random House LLC
375 Hudson Street
New York, New York 10014

Most Avery books are available at special quantity discounts for bulk purchase for sales promotions,
premiums, fund-raising, and educational needs. Special books or book excerpts also can be created
to fit specific needs. For details, write SpecialMarkets@penguinrandomhouse.com.

ISBN 9780525535164
ebook ISBN 9780525535171

Printed in the United States of America
10 9 8 7 6 5 4 3 2 1

Book design by Ashley Tucker

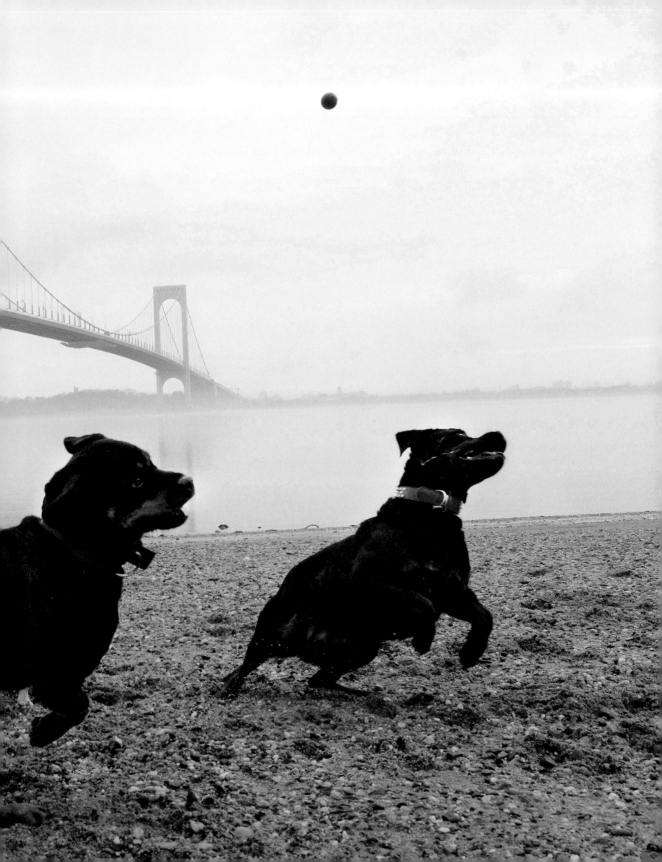

CONTENTS

A CITY OF RESCUES 159

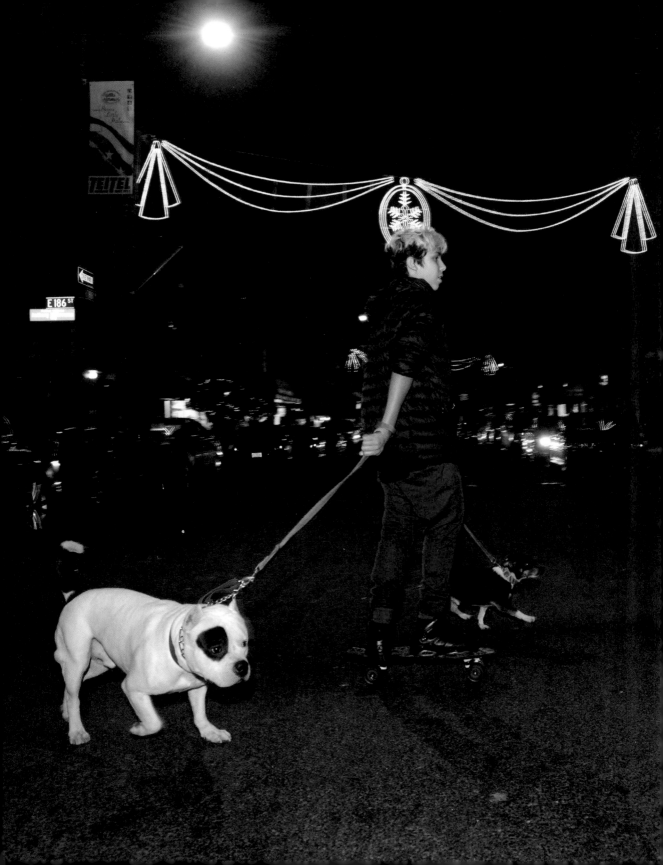

I THOUGHT I WAS
A DOG PERSON

I am not a people person, I am a dog person. This means that I am much more comfortable around dogs than people. Always. People make me nervous: they are complicated and unpredictable. Dogs are rarely either. I understand dogs, and they understand me. Dogs have shaped how and what I love; they have defined my career and continue to inspire and comfort me every day.

When Ken asked me to join him on this project, I knew that I would love meeting and photographing forty New York dogs, but what surprised me was the powerful friendship and instant bond that I often felt with our human subjects.

Doing a photo shoot is always an intense experience. It's invasive, collaborative, and exhausting. Time stops while I have a camera in my hand. I am not myself—I am better. I have no limits or worries or awareness, I just am. And when I "come to," I have the images to remind me of the crazy, beautiful unrehearsed thing that just happened. For *City of Dogs*, we were entering people's lives in an extraordinarily intimate way. We came to their neighborhoods, we learned all about their family history, their love lives, their kids, their workplaces, and their sanctuaries.

On many occasions we saw the good along with the bad, but on great days, we uncovered that vulnerable self that crouches under "the face that [we keep] in a jar by the door," as the Beatles said. This more private self is not always what I photographed—in some cases, it wasn't the right choice—but what I found utterly amazing was that the deeper we dug and the closer we got to the core of our subjects, the more we discovered that these were all really good people. Not being a people person, I found this to be a life-affirming realization.

Growing up in North Carolina, I always had a bit of a love/hate relationship with New York City. I feared the gritty, graffitied New York City of crime dramas but also felt like it was probably the place to be. At the beginning of my career, it was still the norm for aspiring artists to head to Manhattan or LA. I resisted and moved to Providence but remember telling my boyfriend (who later became my husband) that I would have to move to New York eventually, so he'd better be prepared to come with me. For better or worse, the art and photo industry shifted massively in the early 2000s. With digital workflow and the Internet, it mattered less and less where

you lived. Artists were no longer clustered in one of two metropolises but all over the country in small towns, cities, and the middle of nowhere. We could all access one another and work from anywhere. I love Providence, so I stayed there. But I've always had this little itch in the back of my mind about living in New York, even just for a little while. Making this book gave me the chance to be a kind of honorary New Yorker. Photographing more than a hundred locations in all five boroughs, I have now seen more of New York City than many New Yorkers ever do. I've been to landmarks and hidden gems, teeny apartments and majestic town houses, not to mention just about every vegan restaurant in the greater metropolitan area.

Ken wore many hats in the making of this book. He was a location scout, an incredible and inexhaustible resource for finding subjects, a driver who schlepped us from shoot to shoot, and a photo assistant, holding reflectors and light stands, often in unfavorable weather. Ken was very dedicated to our mission, which was to represent, as best we could, *all* of New York, not just the hip streets of Brooklyn and posh Manhattan hoods, but as many neighborhoods as possible through their remarkably diverse canine and human residents. We could have gone on forever and made an encyclopedic opus, but forty seemed like a good place to stop. Obviously there are many places, and types of people and dogs, that we couldn't fit in, but we have an amazingly diverse, exciting array of subjects, both canine and human, whose ages range from infant to senior and everything in between. We have mutts and mongrels, pure breeds and show dogs. We have teachers, writers, artists, performers, construction workers, accountants, lawyers, animal-welfare workers, doctors, shop owners, athletes, office workers, and more. But most important, in the end, I feel certain that we could chuck this large, somewhat random selection of New Yorkers who are so racially, economically, and culturally varied in one room together and they would all get along, because at their core, they are dog people. Loving and needing dogs in our lives is something that brings us together, no matter how different we are in other ways.

TRAER SCOTT

AN ANTHOLOGY OF DOGS

I grew up in Central Pennsylvania, but New York was always "the City." My parents would load us up into our station wagon and drive to a Midtown hotel, leaving behind a houseful of cats, hermit crabs, tropical fish, and one single Samoyed for a temporary life of museum hopping and side trips to FAO Schwarz and Creative Playthings. Our home was full of pets; our city adventures were completely absent of them.

Later, as an adult living in the East Village, my understanding of my community was completely transformed when I adopted Brando, a brindle mystery dog who was simultaneously more than I could handle and everything I needed. With Brando, I had explored the city beyond our own territory, walking west to Greenwich Village or south to the Financial District or north, along the East River, to the United Nations. How had I managed a life in the city without a dog?

We moved to Florida, and then Mississippi, and finally New Orleans, collecting a few dogs into the pack at each stop. Like many New Yorkers, when I left, I never intended to come back. Leaving New York City is like leaving your most intense, dysfunctional lover or your most disappointing best friend. By the time you finally leave it, you know it is for good. And then something lures you back. For me, it was a variety of things—and losses—that made the return seem inevitable. Two close friends died unexpectedly, and both of my parents, and then Brando, who had always been the one piece of New York that was at my side.

The additional lure—the one that made returning impossible to resist—was a job that I was invited to create with the Animal Care Centers of NYC, which run the city shelters. As the Community Dogs program coordinator (now Community Pets), I would be creating owner support programs to keep animals out of the city shelters: free vaccination clinics, free dog training, a pet-food pantry. All of these programs would take place in the Bronx, a borough I had never spent any time in. Honestly, I had really never spent time outside of Manhattan aside from an occasional trip to Brooklyn. What an opportunity!

As I set out to learn all about the Bronx, I discovered the things I already knew: that our pets make connections of all kinds possible, no matter what neighborhood we are in, or what languages we speak, or what our other priorities might be. I also realized that I'd been missing out on one of the most amazing places in the world, one of New York's secrets, the amazing borough of the Bronx. I wanted to get to know the entire city this way, this City of Dogs.

Twenty years ago, my first published book was an anthology of writers who had participated in a reading series I had curated at the KGB Bar on East 4th Street. The first writer in that collection was Jacqueline Woodson. She doesn't know this, but when I pitched that book the entire point, as far as I was concerned, was that the book would begin with her story. Since *City of Dogs* would essentially be an anthology of dogs, it seemed we ought to begin with Jackie's dogs representing Brooklyn, if she let us. Oz, Noah Neiman's dog, convinced me that I could try one of Noah's boxing classes—because if he could train a dog, maybe there was hope for me. This is one of the wonders of dogs: they can connect us to people with whom we might otherwise think we had no common bond and they can make us better, healthier people. It wasn't until we arrived at Noah's apartment roof deck for his photo shoot that I realized that he lived just half a block from KGB, in a neighborhood that has changed quite a bit since I lived my life there with Brando in the '90s. I sketched out a few more examples from people I knew but didn't know well enough yet to know that they would be interested: Majora Carter, who I met on my first visit to Hunts Point; Alexander Nuckel, who was a client of our pet-food pantry; Monet, who had written to me years ago about the Rottweiler she'd lost in a house fire.

But the book needed more than just a few people with whom I had a faint thread of connection. Doing the book right meant finding strangers in neighborhoods I'd never visited. It meant figuring out Queens and Staten Island, which remained, up until then, just abstract ideas to me rather than actual, concrete places I'd visited. It is possible to live an entire life in the city without fully seeing it. But everywhere Traer and I went offered unexpected discoveries: extraordinary geography, stunning (and sometimes puzzling) architecture, and, of course, the people. The people! At the end of every shoot, as we drove off in my tiny Fiat, we would talk about the people with a mixture of awe and misplaced parental concern. We wanted the best for them, and their kids, and the dogs. There are several families that I still daydream about being adopted into.

There was another narrative theme that emerged as we created this book: the story of real estate and how it shapes our lives. It was hard for anyone to tell the story of their dog without also hearing about how they at some point had to move and make the choice to find a place where their dogs would be welcome. In some cases, the narrative ran in the opposite direction and it was a move or a breakup that allowed them for the first time to recognize the need for a dog. And there were a few people who were concerned about participating because they weren't sure what would happen if their landlord found out about the dog. But in every case, what we were seeing were individuals and families and communities who were made better, happier, and stronger by the dogs among them.

Why don't I live here? I asked myself, again and again, in the Bronx and in Queens and in beautiful Staten Island. Although my dogs have settled in quite nicely in the Hudson Valley, an hour north of the city, maybe someday I'll bring Doug and Bananas in and show them where their old friend Brando came from, because if not for him, they wouldn't be here with me now.

KEN FOSTER

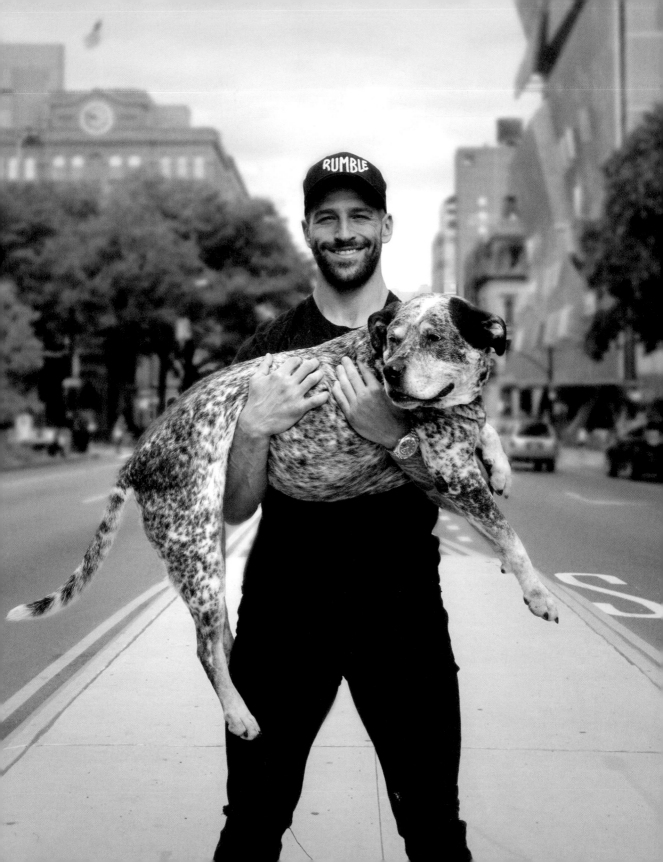

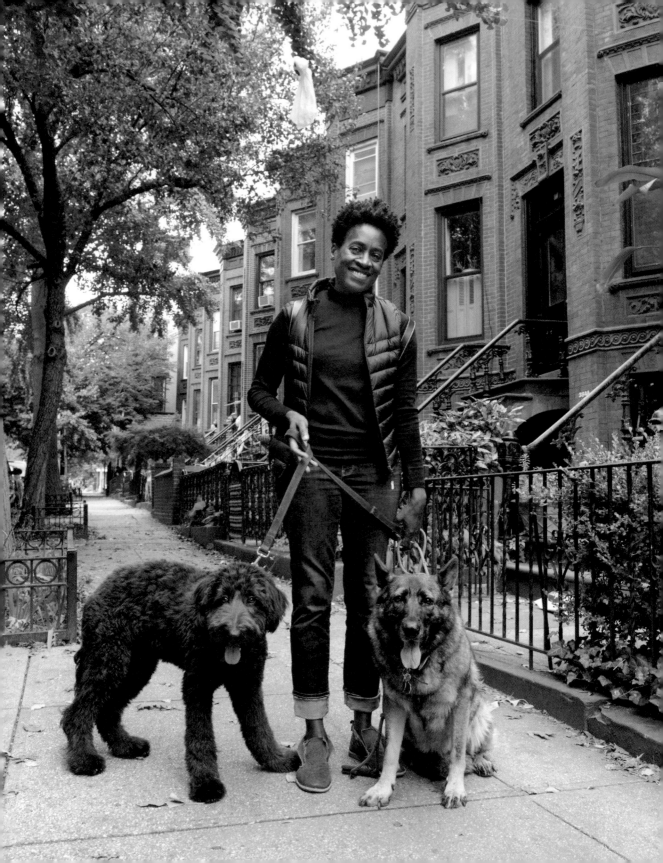

TOFFEE AND SHADOW & JACQUELINE

PARK SLOPE, BROOKLYN

"We were learning to walk the Brooklyn streets as though we had always belonged to them—our voices loud, our laughter even louder," Jacqueline Woodson wrote in her novel *Another Brooklyn*. "But Brooklyn had longer nails and sharper blades." These days, Jackie is teaching her newest dog, Shadow, how to walk those streets. Shadow is a recent transplant from the South, just as Jackie and her family were back in the 1970s. As she walks Shadow and her elder dog, Toffee, it is both easy and hard to see how much the neighborhoods have changed and how much they remain the same.

Jackie is the author of more than two dozen books for children and young adults; her work often lifts memories and observations from her younger days in Bushwick, which she remembers as "a neighborhood of strivers." The details make her stories resonate as autobiography, even when the characters are fully conjured from her imagination. But one thing you won't find in her work is any mention of dogs. "Yeah," she admits, "dogs don't really make it into my work because I do try to keep my work separate from my life. My dogs are more 'backstage' for me—serving as the calm at home, the muses—and sometimes the anti-muses."

Animals were always a part of her life, al-though one particular dog breed was long cast as the villain. "My mom was an animal lover and any animal we brought home, she immediately banned, then loved," she says. "We usually brought home kittens that grew into backyard cats. When I was about seven, the German shepherd who lived on the top floor snuck down to our basement and killed our kitten—a yellow tabby named Sweetie. Sweetie had a broken back and had to drag his back legs when he walked. But he was fast as hell. Still, he couldn't outrun the neighbor's shepherd. My mother let all of us stay home from school that day. Basically, we stayed in our beds and sobbed—including my mother. When I was fourteen, I got bitten by a German shepherd named King who lived on the block. That pretty much sealed the fate of German shepherds for me—I hated them."

But then, when she was in her early thirties, a friend asked her to watch over a sickly puppy she had found on the streets. "She already had four dogs, and her husband put his foot down on more coming in. I didn't name the puppy, but by the third week in my tiny apartment, I knew I wasn't going to let her go anywhere. At the time, I was reading Art Spiegelman and decided to name her Maus because she so looked like one of his illustrations. Maus turned out to be a full-bred

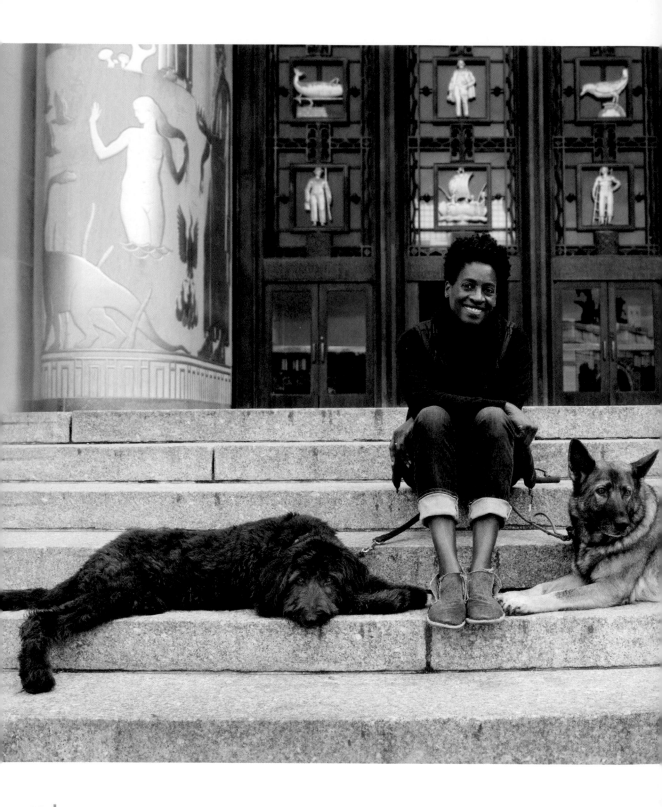

Belgian shepherd—a black shepherd. My love for shepherds—because she was so amazingly sweet—was renewed. She loved babies and children. But then one morning, because I had to catch an early flight, I walked her at five a.m. From out of nowhere, a man started coming fast toward me and Maus went ballistic. He ran off. After that, I knew I had a dog that was not only extremely loving but fiercely protective. When Maus died at around thirteen, the whole family was shattered. But from that point on, I was a true lover of shepherds—and shepherd mixes."

After Maus came Toffee, and now a gigantic shepherd poodle mix, Shadow, whom they briefly considered naming Muppet, because he looks like he could be related to Elmo or Cookie Monster. "When I'm not working, I love taking Toffee around. She's very slow-moving these days, so she makes me slow down a lot. Shadow is still a puppy, so he's a nut and is still barking at other dogs. Walks with him tend to be less relaxing unless we head to the park, where he can be off-leash a bit and get out the crazies."

Their Park Slope neighborhood offers a lot of territory to explore, from the iconic Art Deco façade of the Brooklyn Public Library to the lush sprawl of Prospect Park. "To watch your home change in front of you is surprising," she said in an interview with the *Rumpus*. "Even with all of its changing, Brooklyn's architecture still feels like home; the language feels like home." But as enticing as it is for a writer and two dogs to explore, it is just as rewarding to retreat back to the brownstone they call home, where they can each occupy themselves within their imaginations for an afternoon, and wait for the kids to come home.

OZ & NOAH
NOHO, MANHATTAN

In the lobby of Rumble Boxing, next to the chilly white reception desk and across from the framed Basquiat skull, Oz is patiently waiting. Or perhaps not so patiently. He's perfectly well behaved and briefly greets visitors, but he really only cares about one thing: Oz has his eyes fixed on the boxing studio door. As soon as the class on the other side wraps up and the music dims, he knows that—after a forty-five-minute separation that apparently feels like forever—he will be reunited with Noah.

Noah reciprocates the sentiment. He peppers his monologue to the class with references to his best friend. "I'd introduce you to my parents before I'd introduce you to my dog," he says. But then he offers a meet-and-greet with Oz as a postworkout reward. "You can ask us anything," he tells the packed room of sixty sweating boxers, many of them young, deceptively frail-looking, aspiring models.

When the door finally cracks open, Oz can no longer contain himself and scampers to Noah's side while Noah bumps fists with his students as they file out. But Oz and Noah never have time to linger, because there's always something pressing to get to, so Noah retrieves Oz's leash from the desk staff and off they go: to a meeting, to the Broken Coconut for a smoothie (but nothing for Oz!?),

to check in with the doorman at home on their way up to the roof deck, with Oz sniff-counting the passing floors in the elevator.

When things are really busy, Oz might get dropped off at doggie daycare or with an ex. Oz is ten, but keeping track of Noah keeps him young, and he's better at it than anyone else around—he's been at it since he was just a few weeks old.

NoHo is a neighborhood defined by the neighborhoods that surround it and by its convenient proximity not only to them but also to the subway lines that lead from home to anywhere. Facing uptown, you have the East Village on one side and the West Village on the other, with Nolita, SoHo, and the Lower East Side just a few blocks south. It makes a perfect home base for an entrepreneur with clients and business partners all around town. And it's just as convenient for a dog who likes to split his time between multiple parks.

At thirty-two, Noah has had Oz at his side for a third of his life, and in that decade he's gone from a typically uncertain young adult, to a successful trainer, to the cofounder of a national chain of boxing studios. All, perhaps, to maintain Oz in the lifestyle he deserves. Some people say that having a dog in the city is an unnecessary burden. These two would emphatically disagree.

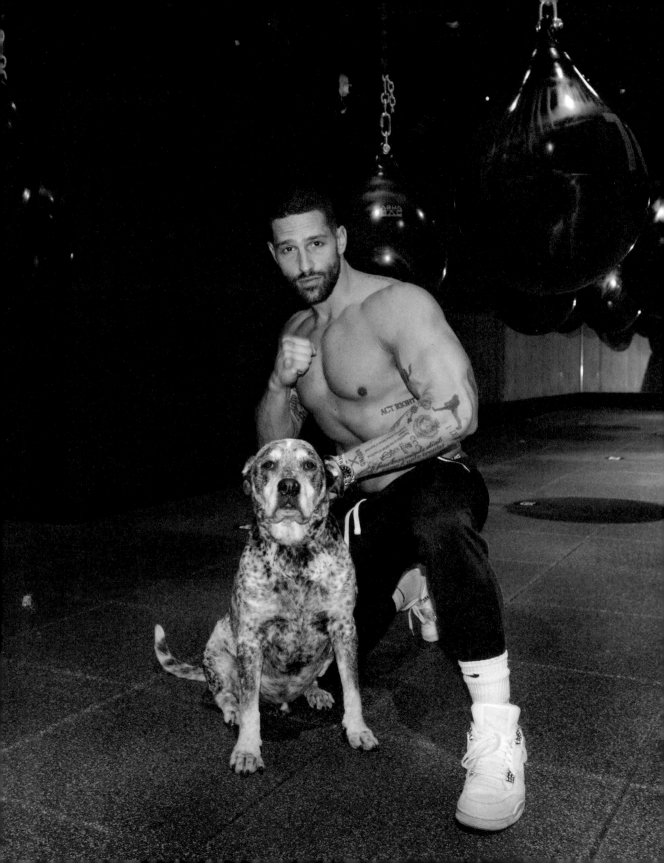

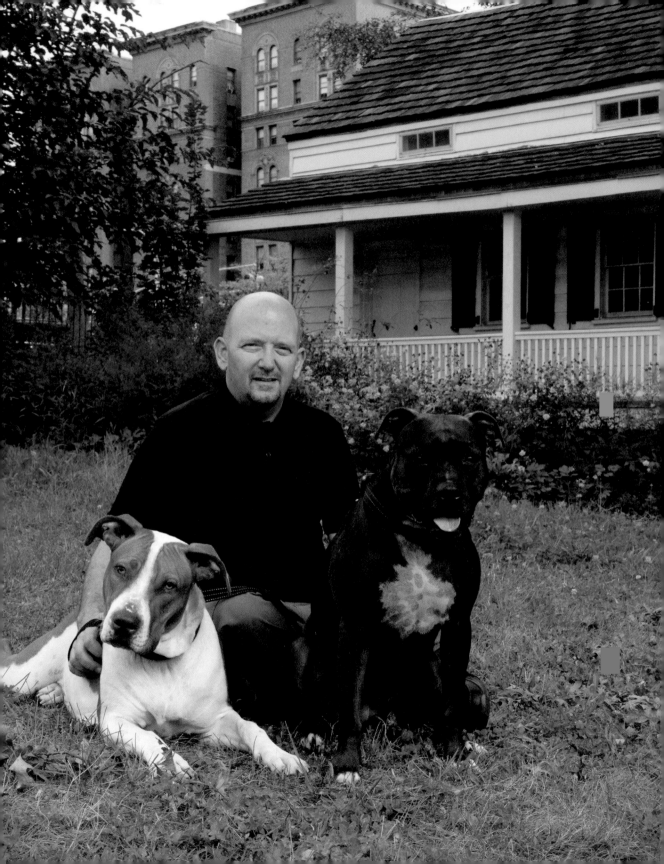

LUCI AND MAX & ALEX

FORDHAM MANOR, THE BRONX

Alex isn't as tough as he looks, and neither are his dogs. He moved back north after getting his degree in psychology in Miami and then doing time in jail for racketeering. At first, Alex wasn't an ideal inmate, so they shipped him from Miami to Fort Dix in a black box. "It's called diesel therapy," he explains—the only way they feel safe transporting a prisoner who has been "trouble." There, he worked on the inmates' newspaper and received a writing award. Now he lives on disability, most of which goes to cover his rent in a small, dark apartment on the Grand Concourse, a majestic relic of Bronx history, lined with enormous, classically European apartment houses in various states of up-keep, their cavernous lobbies now barren of furnishings to discourage loitering. In the park across the street, a small cottage stands, surrounded by a grassy mound: Edgar Allan Poe's final residence, another of the hidden highlights of the borough.

"We're best friends," he says, gesturing toward Luci, his black pit bull. "We're together all the time." When he returned to New York after thirty-one months at Fort Dix, Luci found him at a barbershop where he had started hanging out. He was assigned to a halfway house on Creston Avenue in the Bronx, but it wasn't until he met Luci that he got clean, stopped smoking, and refocused his life.

Max was a stray. A friend initially took him in but found him a bit much to handle, so Alex brought him home to Luci. Over the months, the neighborhood watched Max morph from a pit bull puppy to an elongated hound dog and then back into something closer to a pit bull again as he worked his way through canine adolescence. Now the dogs keep each other out of trouble—and keep Alex out of trouble, too. "I can't work. I have a condition," he says, tapping his head. "They're all I have in the city."

Taking care of Luci and Max is what Alex considers to be his job, and they know all the dogs in the neighborhood and their owners, too. They might head down to Fordham Road, a busy commercial district, or hike up to Fort Independence Park on the other side of the reservoir. Alex shares advice with his fellow dog-owning neighbors about where to go for low-cost veterinary services and other forms of assistance. A lot of his neighbors with small dogs can't afford to get them groomed. "Maybe I should find out how to do that," Alex says, because he can understand, perhaps more than anyone, how important our pets are when life hasn't sent a lot of breaks our way.

"If I didn't have my pets," he says. "I don't know where I'd be."

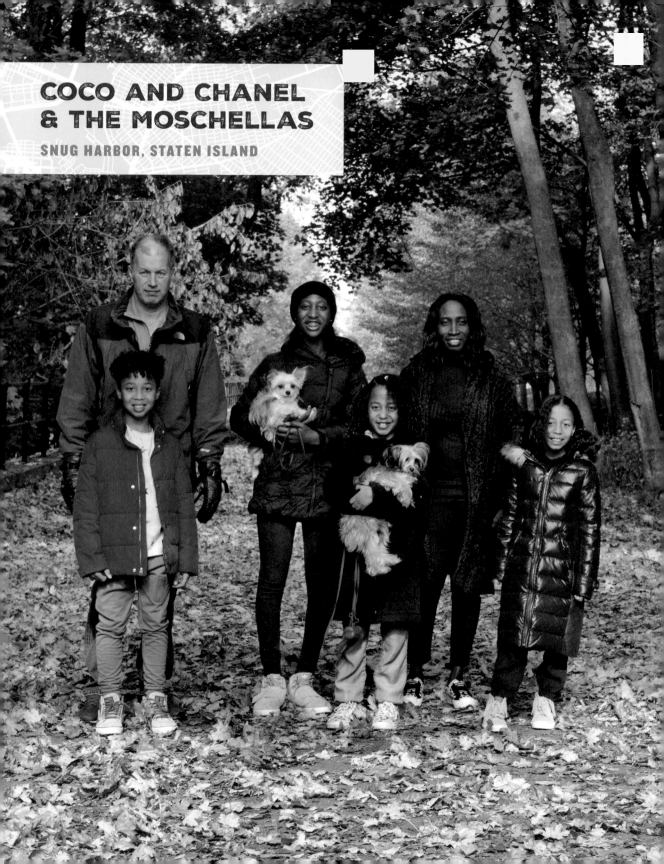

COCO AND CHANEL
& THE MOSCHELLAS

SNUG HARBOR, STATEN ISLAND

The Moschellas weren't planning on two dogs, but that's what happened. After agreeing to adopt a dog sent via transport from Arkansas, the family arrived at the pickup only to learn that the adopters for their new pup's littermate were no-shows. So they went from zero dogs to two.

But the Moschellas are used to unexpected arrivals. Several months into Amy's second pregnancy, while they were on a trip to visit Joe's family in New Orleans, she began to worry that something didn't feel right; the feeling hit her as they were driving across the Lake Pontchartrain Causeway, a twenty-three-mile bridge that connects the north and south shores of the lake. When they returned to New York, she called her husband into their doctor's office to break the news: there wasn't one heartbeat—there were three. Now those three babies are eight years old, and they happily fill in the details of their own first days on earth: how small they were, how often their mother had to feed them until they grew stronger. They have obviously heard the story so often, it may seem like a memory rather than family lore.

You might expect chaos in a household with four children, including three eight-year-olds, and two dogs, but the Moschella home is serene. Amy's calm sensibility influences everyone from the top down: husband, Joe; their oldest daughter, Saran; the triplets, Gabriel, Rita, and Margaret; and, of course, Coco and Chanel, the family dogs.

Joe works for the city transit authority. Before he met Amy, he traveled the world and fell in love with Africa. Amy is from Guinea but marvels at her husband's self-study. "You should see his library of books," she says. "He knows more about African history than I do!" He'd even considered adopting a child from Africa on his own, but then he met Amy. Now, the world is waiting for him when he comes home at the end of the day.

Their home is just a short drive to Snug Harbor, a stunning arts complex and botanical gardens. Every borough of the city has its own secret wonders, places that residents are glad very few people from outside might know. Snug Harbor is one of those places. It was originally a home for retired seamen, and its 130 acres are lushly landscaped and dotted with historic structures, including five Greek Revival buildings, and small cottages that are now used as artist residencies. There's a secret garden with a hedge maze for the kids to run through, and plenty of trails for the family to tread, though the dogs often prefer to be carried, and the kids might like to argue—calmly—about who gets to hold them first.

The dogs sometimes join the kids at soccer practice and official matches, where Saran has emerged as the family's star. There's always a lot of activity, which may contribute to the sense of peace at home. By the time this crew is reassembled back at their house, there's not much energy left to expend.

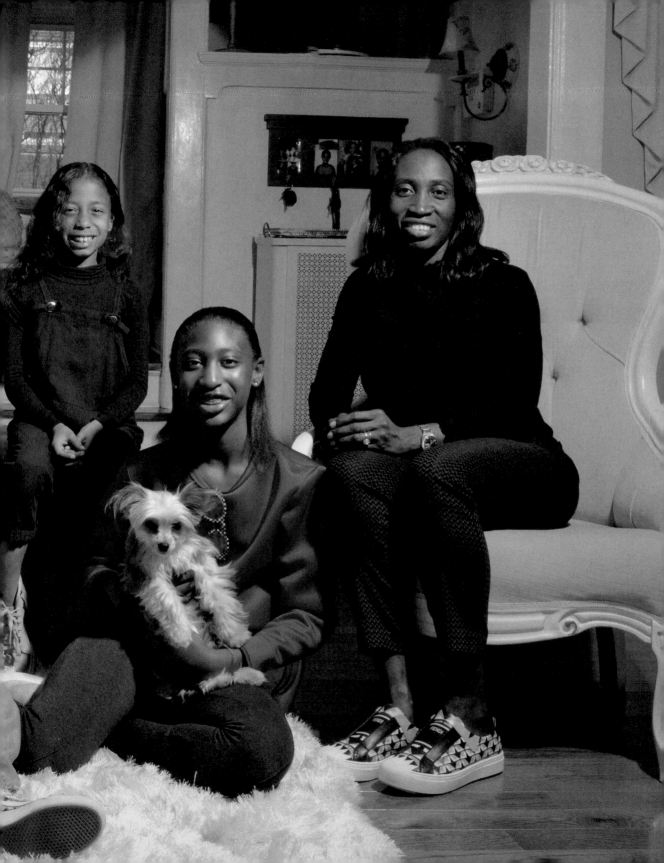

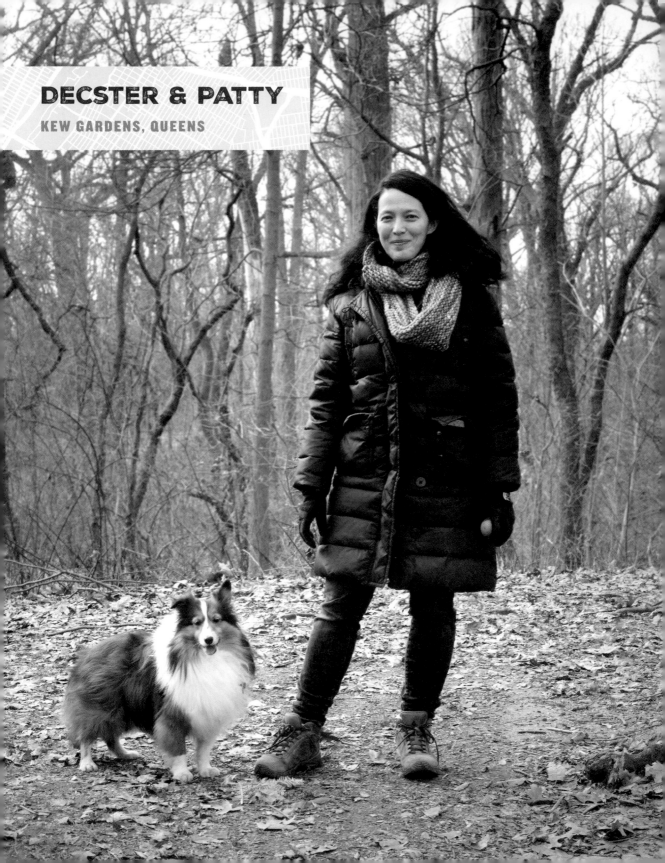

DECSTER & PATTY
KEW GARDENS, QUEENS

Getting Decster was a spontaneous decision. Patty was walking down Metropolitan Avenue in Forest Hills when she decided to stop into a pet store that she'd never had the urge to explore before. Decster was four months old, the last of his litter. The store kept the puppies on display in human cribs.

"I was drawn to a Sheltie sitting quietly in a corner and avoiding eye contact, the only pup not barking to get my attention," she says. "He was gentle and shy, and he almost seemed sad. I learned that his two sisters had just left for their new homes. My partner met me at the shop, and we decided to bring him home with us that day. It was October 10, 2010. This is how he came to be called Decster."

They spent a year in New York City before moving to the coast of Maine in July 2011. Her partner had just accepted a position at the University of Maine, and Patty was looking forward to rural living at what had been her vacation home for four summers, which she referred to as the Peaceful Perch. Decs and Patty took long walks in the woods behind the house and down to the beach every afternoon. They both loved being outdoors and spent their days eagerly exploring their new environment.

Then one day, just a few months into this big move, Patty's partner came home and announced she was leaving. "I understood falling out of love with your partner. But abandoning Decster? This was unthinkable to me."

So then there they were—Patty and Decs, alone together, five hundred miles from home. "I struggled to meet my own basic needs," Patty remembers. "Irrational thoughts set in. Decster was good at pulling me out of my funk—no matter what I was going through, he still needed to be fed and walked, to run and play. He needed attention, and he would remind me of this as often as needed." She even considered giving Decs to a friend, but the friend refused, telling her later that he was worried about what might happen to her if she was left completely alone. Decster was giving her purpose.

"Over time, I grew stronger," she remembers. "Our walks together supported me. We spent three years in Maine, hiking remote areas of the North Woods, trekking across frozen ponds in winter, camping on lonely islands under billions of stars. We made a good team. We still do." These days they are back in New York, living in a small studio apartment not far from where they first met and exploring the city's own woods, Forest Park, which stretches over 530 acres in the middle of Queens. They also have the diverse residential and commercial neighborhood to explore, including Kew & Willow, a new community-funded bookstore where she and Decs find inspiration in literature and local publications such as *Walking Queens*.

For the past two summers, Patty has hiked the coasts of Ireland and Scotland, but she's realized that the amount of time she spends on WhatsApp with Decs and his sitter suggests it may be better to stick closer to home. "When we can get away from the city, our walks include weekend hikes in the Catskills," she says. "I have summers off, and recently I've been interested in buying a small cabin in the woods so that we can ramble for hours, days, weeks without interruption. We are looking forward to this next chapter."

FREYJA & JOANIE

LOWER EAST SIDE, MANHATTAN

Although Freyja and Joanie live in Nolita, their territory covers a much wider terrain. They love walking through Tribeca and along the Hudson River on the west side of the city. But when it's nice out they walk in the opposite direction, crossing the East River into Brooklyn via the Williamsburg Bridge. "I find that having her with me forces me to be outside and explore different areas of the city," Joanie says. This part of Lower Manhattan still displays the remnants of its origins as a garment district, with old warehouses and factories nestled among tiny tenements once populated by the families that worked there. But like many other parts of the city, the older generations have been pushed out by rising rents. They were displaced by the creative class, and now the artists are being replaced by people who can pay those astronomical rents. Displacement, though, is nothing new here; the construction of the Williamsburg Bridge at the turn of the nineteenth century kicked nearly ten thousand people out of their homes.

Joanie and Freyja bridge multiple worlds. Joanie works at a film production company, and she has a hand in many alternative creative endeavors, like curating pop-up galleries downtown. Freyja is a Puerto Rican street dog. Together, they make a perfect pair. They may seem a bit cool to strangers, because they really are cooler than most. Freyja, in particular, carries the sense of having seen it all before. She's not difficult or even shy, but you've got to earn her attention, and once you have it, you know the ultimate compliment has been paid.

Joanie is among those lucky New Yorkers who can bring their dog to work. While Joanie meets with clients, Freyja lounges at her feet or heads off to reception and rests on the carpet in front of the empty chairs. "Freyja brings so much joy and energy to the office," Joanie says. "Several people have said that having her around is therapeutic. She has free rein of all three floors. She greets all the clients and puts a smile on everyone's face."

"I've had several dogs at different stages of my life," Joanie says. "A mixed breed, German shepherd, Rottweiler, and Labrador. They each had their unique personalities. Freyja is the most independent. Almost catlike. She is incredibly gentle and sweet. Also a charming flirt who loves attention and definitely knows how to use her big blue eyes."

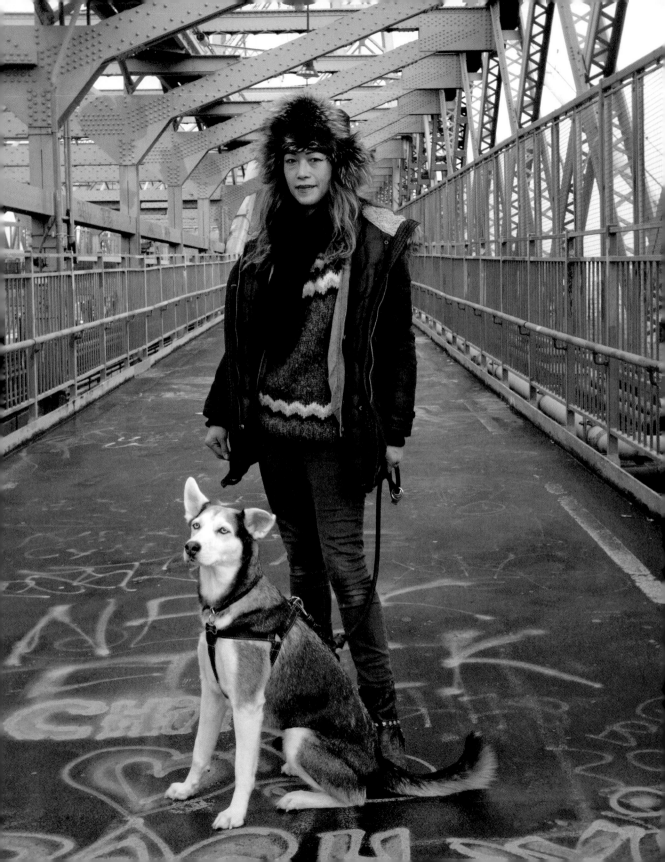

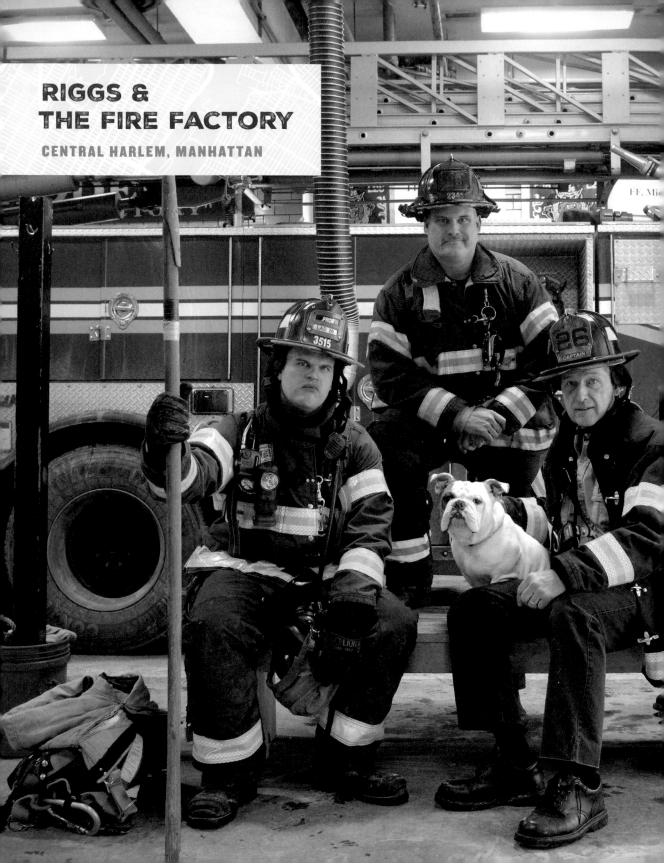

RIGGS &
THE FIRE FACTORY

CENTRAL HARLEM, MANHATTAN

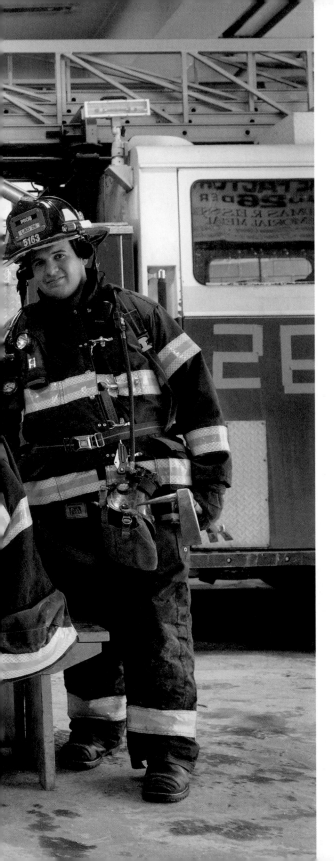

Engine Company 58 Ladder 26 is on 5th Avenue just above Central Park; it's also called the Fire Factory, a nickname from the 1960s, when Harlem and the Bronx were experiencing a period of arson. The excessive fires stopped, but the name stuck, and so did their mascot, an intense-looking bulldog pictured on many of the artifacts that decorate the firehouse: signs, flags, even a stained-glass window. But Riggs, a recent addition to the team, has no idea of the history before he arrived. At just eight months, he thinks having a whole team of men looking after him is completely normal.

Fire dogs are a storied tradition. Initially their purpose was to act as companions and guards to the fire horses. When engines replaced horses, the dogs stayed, now as companions to the men. New York City firehouses are populated these days with a variety of breeds and mutts, many of them rescued from the streets, often by the firemen themselves while on a call. Riggs was a gift from one of the men here, after their previous pup had been gone too long.

Riggs throws himself into his bed in the corner of the command center: this is his spot, surrounded by toys and, with the door closed, safe from any unexpected action in the garage. He watches the team come and go, on and off their shifts, out to calls and back again. When they pile into their boots and gear and drive off, Riggs deflates like a balloon. They will be back, and when they return, whether it's been an hour or a day, Riggs is ready to welcome them home.

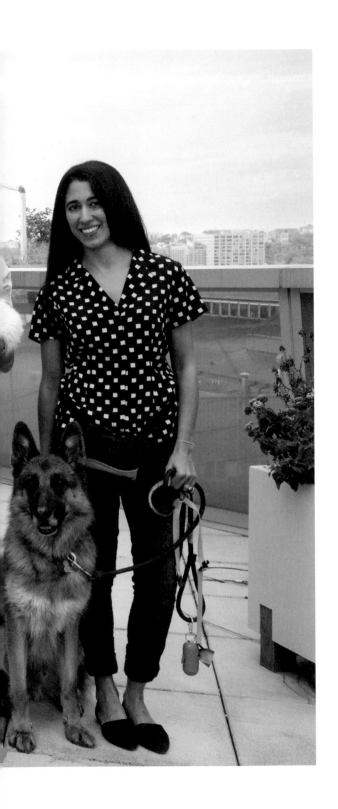

THE DOGS OF THE IAC BUILDING

CHELSEA, MANHATTAN

Is it an enormous iceberg? Or a giant paper lantern? At the western end of 18th Street, the Frank Gehry–designed IAC Building stirs a lot of debate. One of the first of a flurry of high-rises along downtown Manhattan's west side, it houses multiple elements of Barry Diller's media empire, including the *Daily Beast* and Vimeo. As sleek as the exterior is, the atmosphere inside is incredibly welcoming, with natural light and open workspaces punctuated by well-stocked snack stations. And on the first Friday of the month, there are dogs.

Near the central stairwell, Michelle and Beau are playing a quick game of fetch with his favorite rope toy, but soon they'll be back in her office, focused on the task at hand, which is actually Michelle's work, though Beau seems to think that they may have come to this fabulous building just to play tug with a rope. Around the corner, Rex and Marites are at work behind a desk; Marites was, in fact, looking for a desk on Craigslist when she found a dog instead. "Aside from my family, the city has always been my greatest love," she says. "Having Rex takes that to a whole new level; we're always discovering new things." The impulse to investigate sometimes sends him scurrying into another office when he hears the rustle of a plastic bag.

Duck into another office and you'll meet Bella, a fourteen-year-old Chihuahua at the opposite end of the dog-age scale. Chuy, Bella's human, grew up in Mexico, surrounded by German shepherds and Irish setters, hiking in the mountains of Monterrey. Fourteen years ago, he found her on the side of a road and they've been together ever since. Although she's the tiniest and oldest of the IAC gang, she wields the authority that only comes with age; she's often reported to be eyeing the entire operation with "a stare of judgment." Her attitude isn't limited to the workplace; Chuy says, "Although she's Mexican by birth, when you see her battling the crowds at Grand Central Station, enjoying weekends in the Hamptons, or navigating the streets in Brooklyn, you can definitely see the attitude of a New Yorker in her."

Next up, in size if nothing else, are Rex and Mercer, the Maltese representatives. Mabel inherited Mercer when a friend of her sister couldn't keep him anymore. She knew she wanted a dog one day but wasn't prepared for everything that would change. "Mercer has led me to Riverside Park, Central Park, the Brooklyn Heights Promenade, all these wonderful, peaceful places where she and I can admire the beauty of the city," she says. "I've spoken to more strangers than I ever imagined."

"Mercer is a star at IAC," Mabel says, echoing what many employees say about their own dogs. "She loves to be held like a baby and have her belly rubbed, and my coworkers take turns coming by to say hello to her. They have told me that just holding her for a few minutes helps them relax a great deal. But she's also got quite the side eye."

An abandoned pit bull with a medical issue, Ronnie was fostered by Patrick, who works in Barry's office, until he finally gave in and adopted him.

"I've been in New York City for over ten years now," Patrick says. "In my earlier years I'd make sure I had plans on the weekend—to go out, at times reluctantly, and force myself to be part of the city in which I pay a premium to live—but now I happily stay in with Ronnie, and my boyfriend, on the couch. It's encouraged us to stay home more often, slow our lives a bit, start cooking more ourselves—and he really adds another layer of purpose in my day. When he doesn't come to work with me, I count down the hours until I can come home to him."

Despite Ronnie's physical proximity to the boss, there's one dog who rules them all: Mazzie, a Lab mix. Known on social media as "Mazzie Takes Manhattan," she arrived from Georgia in 2009 and upended all of Tanya's expectations. Tanya thought they would train together for the New York City Marathon while doing work as a therapy-dog team and hobnobbing at the outdoor cafés in Greenwich Village. Mazzie said no. She wasn't accustomed to the bustle of city life and didn't seem interested in experiencing it at all. Tanya and Mazzie learned how to navigate the city from her perspective. And Tanya learned that sometimes our plans and expectations really don't matter as long as we have each other. "Who she was and is wasn't and still aren't suited for distance running, therapy work, and sitting still at cafés," Tanya says. "She is who she is, and just as I am who I am, she doesn't need to explain herself, justify her actions, or change. She has to be the best Mazzie she can be, and it's my job to make sure that

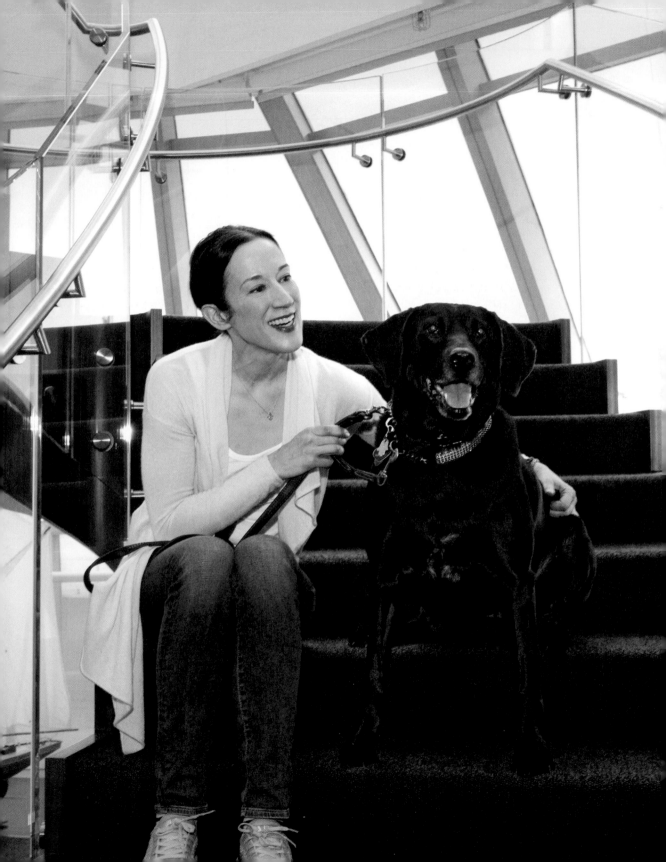

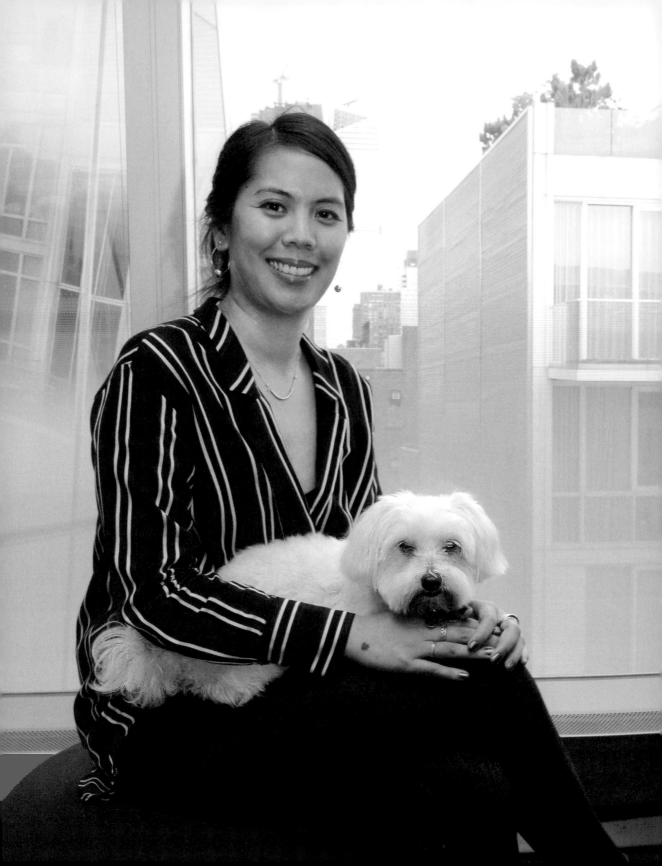

happens." When Mazzie comes to work, she has a routine. She stops at the guard station and searches the trash cans for food. She heads to the eighth floor and searches for food. She accepts visitors in Tanya's office, where colleagues often arrive with questions about how to navigate the city with a high-energy dog. "Through these conversations, I have met more colleagues with whom I would have otherwise never spoken, learned details about the lives of my colleagues and those of their pets that I otherwise would not have, and had an opportunity to educate people about what it really means to meet a given dog's needs. Colleagues now come to me with questions regarding their dogs and when they want to foster or adopt a dog. It's such a privilege to assist my colleagues in this way, and it makes my job feel more like a community and family than it already does. And when colleagues bring their dogs to work, my office is often one of the first stops, which is an added perk."

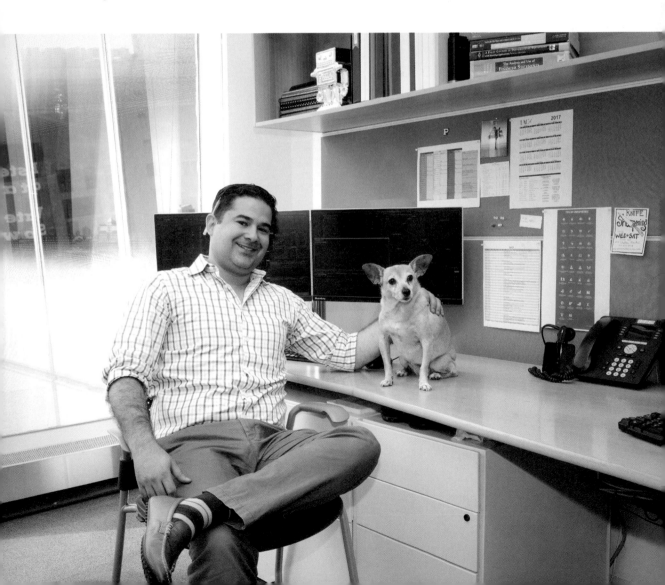

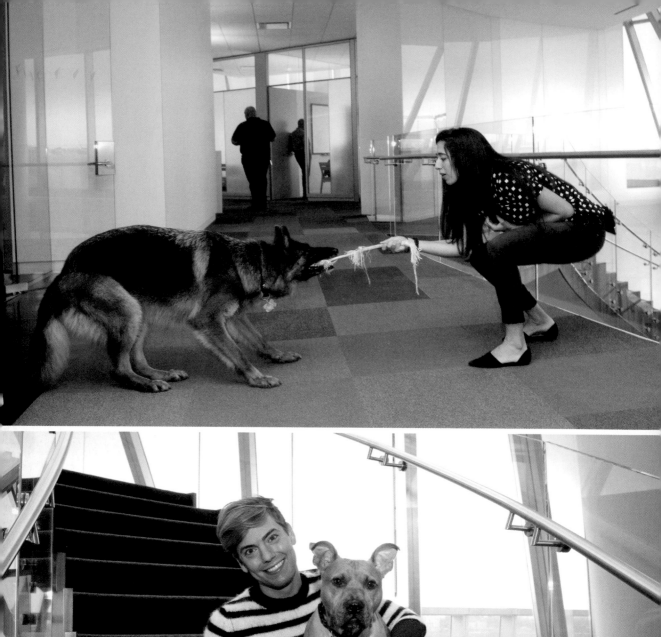
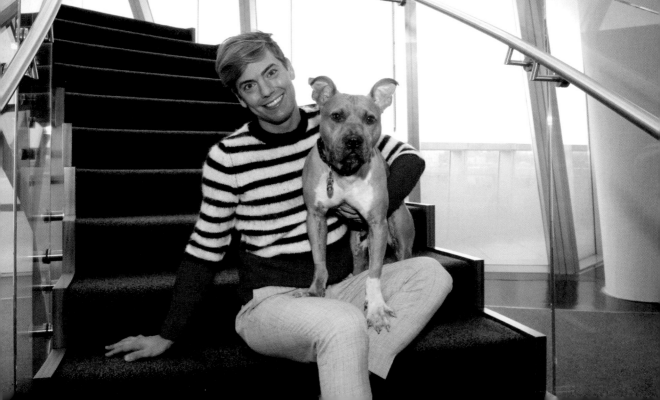

CECIL & TALIA
OAKLAND GARDENS, QUEENS

Cecil is a dog, but he's also an anchor; he keeps Talia from running away. Originally trained by Guiding Eyes for the the Blind, Cecil received new training after his original client passed away. He now specializes in supporting Talia, who has severe autism. Like many kids with autism, Talia was a runner, meaning she was prone to bolt suddenly without regard to her surroundings. Her mother would hold on to her, but that was easier when she was a child. "When you get to a certain age, there's a stigma to having to hold your parent's hand," Talia's mother, Ilana Slaff, explains. Having Cecil gives both of them a sense of security and independence.

It's a huge leap for the family, not just for the support Cecil brings to Talia but also for the resistance he helped them overcome to having a dog at all. Ilana had always regarded dogs as dirty and something that would never be welcome in her home. But she had grown up with two autistic brothers and had seen the benefits that alternative therapies can provide. Now a psychiatrist specializing in autism, she was presenting at a conference when she heard a colleague talk about the benefits of service dogs for

children like Talia. Her position on dogs was instantly reversed.

This was good news to her husband, who had been campaigning for a pet dog to no avail. Now Cecil serves two functions: primarily in service to Talia, but with a side job as house pup for her father. Cecil accompanies Talia every day to school and lies at her side during therapy at home in the afternoon. Part of therapy includes time on a large platform swing that has been installed in the basement, and they also go together to the park nearby to use the swing sets there. They enjoy shopping with Ilana at the grocery store, where they maintain Talia's focus with Cecil on one arm and a shopping bag on the other. Cecil's attention never wavers, at least not until their father comes home; Cecil lights up in his presence and is perhaps a bit torn, though still committed to his task.

As Cecil approaches retirement, Ilana has committed to finding his replacement. Because mobility is essential to being a working dog, Cecil will move to a home where he can be off duty in his senior years. In spite of Ilana's previous misgivings, hers will now always be a one-dog home.

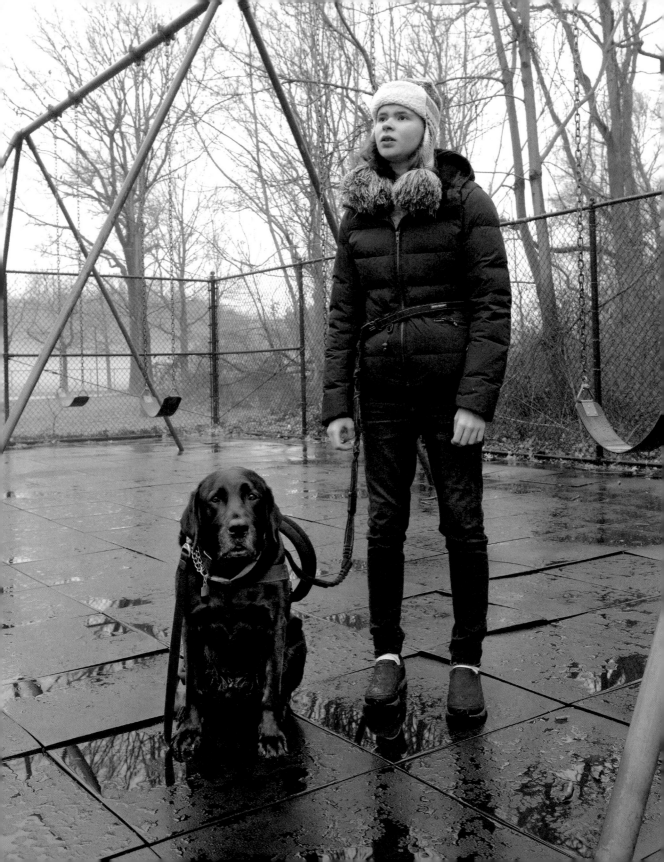

WHISKEY AND KARMA & JASON

BUSH TERMINAL PARK, INDUSTRY CITY, BROOKLYN

Sometimes you just have to get yourself out of the situation you're in. This applies whether you are a human or a dog, and it works even better together. Jason Cohen had a long career in advertising, working his way up to the position of art director before being laid off unexpectedly. But then something funny happened: he realized that he maybe hadn't loved the job as much as he told himself he should. That was when he found a new inspiration.

"I'd been volunteering with an animal rescue group and realized that helping humans and dogs communicate better is the best way to save dogs' lives," Jason says. So he became a dog trainer, not just working with rescue organizations but also helping owners address behavior problems in their homes.

Jason has always been a dog person. "It started back when I was nine years old, living in Israel. One by one by one these dogs were following me, and before I knew it, I had a pack of local strays to keep me company."

Bush Terminal Park started out as a shipping terminal back in the late 1800s, founded by a family of Dutch settlers. It had a rocky start, as Manhattan businesses were reluctant to send merchandise to this new port all the way out in Brooklyn. Soon, though, it

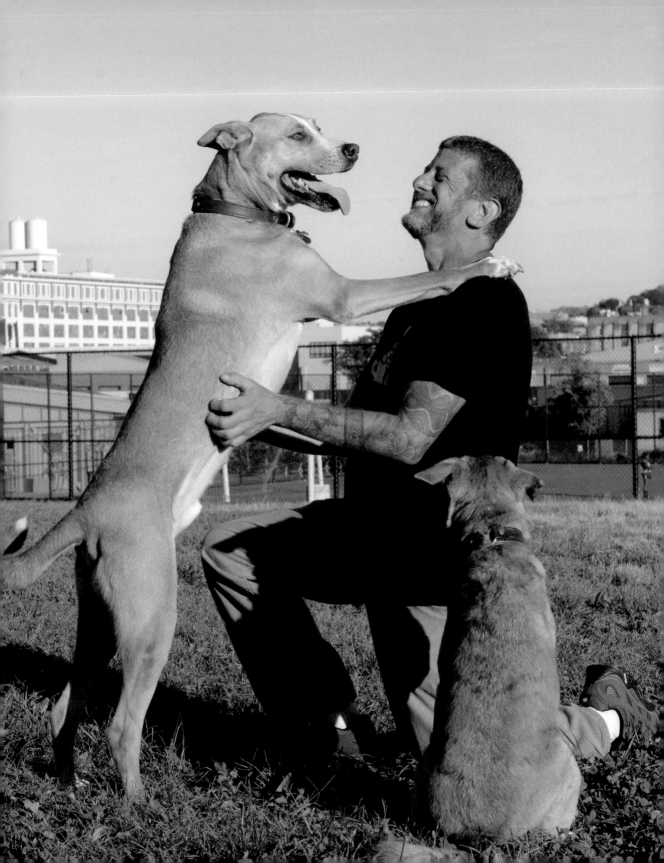

flourished, and manufacturers sprang up around the neighborhood, which is known as Sunset Park. The warehouses, now called Industry City, still house local artists and small businesses, while the waterfront has been returned to public use with landscaped walkways and parks. It's a bit of a mystery to track the path from the other side of the warehouses over the cobblestone streets to the pedestrian path, but the reward when you make it is a remarkable view: across the water to Manhattan on one side, and into the complex of old-world industry on the other.

"Dogs make our lives better, especially in the city," he says while running drills with his dogs, Whiskey and Karma, on one of the hills at Bush Terminal. In the field below, students are playing soccer in the shadow of one of the former warehouses. "They get us out of our small apartments, and for many of us, even in a city full of people, their companionship is important. My last dog saved my life during some very dark times."

Just as the old terminal's role in the community has been reimagined, Jason finds that his old advertising skills work well in his new business: he knows how to market himself and communicate the value of strengthening the bond between people and their canines. Watching as his dogs sit on the hill, waiting for his next command, one wonders what might be next both for him and for this revived stretch of waterfront. Only good things.

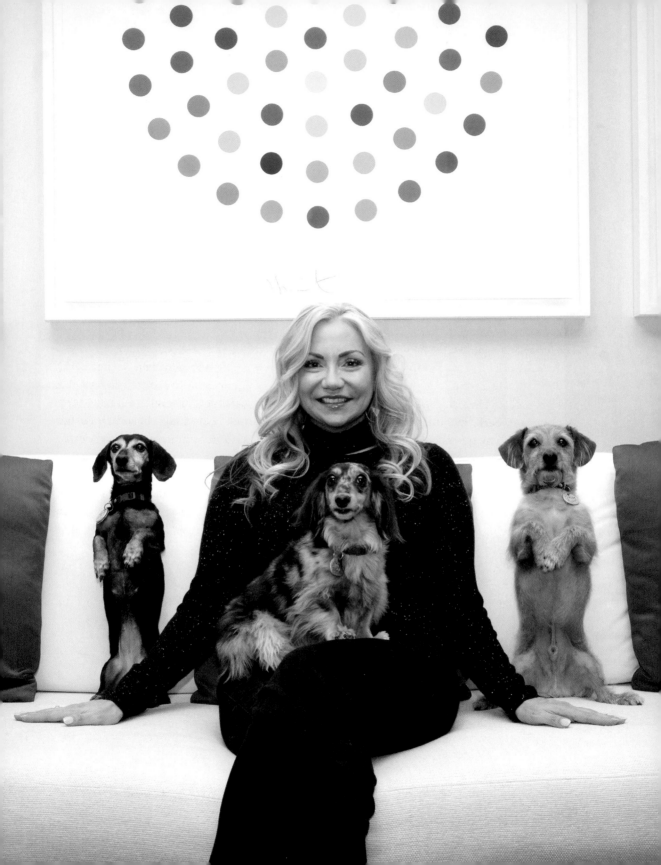

SHANTI, TOBY, AND GITA & LAURA

UPPER EAST SIDE, MANHATTAN

"My favorite place to walk my dogs is actually right down Park Avenue," Laura says. "The sidewalks are nice and wide and I love to see the reactions my dachshunds elicit from people walking by. They make total strangers break into enormous grins every single day. It's a wonderful feeling." Laura and her gaggle of dogs live just a few blocks from the Metropolitan Museum of Art and Central Park, as well as the exclusive shops along Madison and Park, but this tiny trio cuts right through any questions of social class and brings everyone to their level. Dogs are the great, joyful equalizer.

Laura actually has four dogs, but Biscuit, the oldest at fourteen, likes to stay close to home, close to his bed, close to the kitchen. He's the only one who knew Laura's husband, Keith, who died, suddenly and too young, just a week after being diagnosed with peritoneal mesothelioma. A real estate investor, he was responsible for the transformation of some of the city's previously underused properties, including the Chelsea Market, now a hub of that neighborhood.

At the time of Keith's death, their children were just nine and twelve, but as they now establish themselves as young adults, the dogs have taken on the role of the kids in the house. "Adding to our little family through adopting our other dogs not only provided Biscuit with companionship—his lifelong companion, Buster, passed away the same year as my husband—but us with a more expansive family after ours had tragically shrunk," Laura says. In addition to her own dogs, Laura volunteers with a variety of animal charities. Sitting in the music room with her pack, she's surrounded by rare photos and signed guitars from her favorite performers—John Lennon, Mick Jagger, Bruce Springsteen, Bono—all purchased at charity events.

Finding joy after grief is one of the most significant challenges in life. Laura finds hers in her children and her work in the community—and her dogs. "Our dogs have a way like no one else of lifting our spirits," she says. "Even during our darkest moments, they can make us laugh out loud, right through tears."

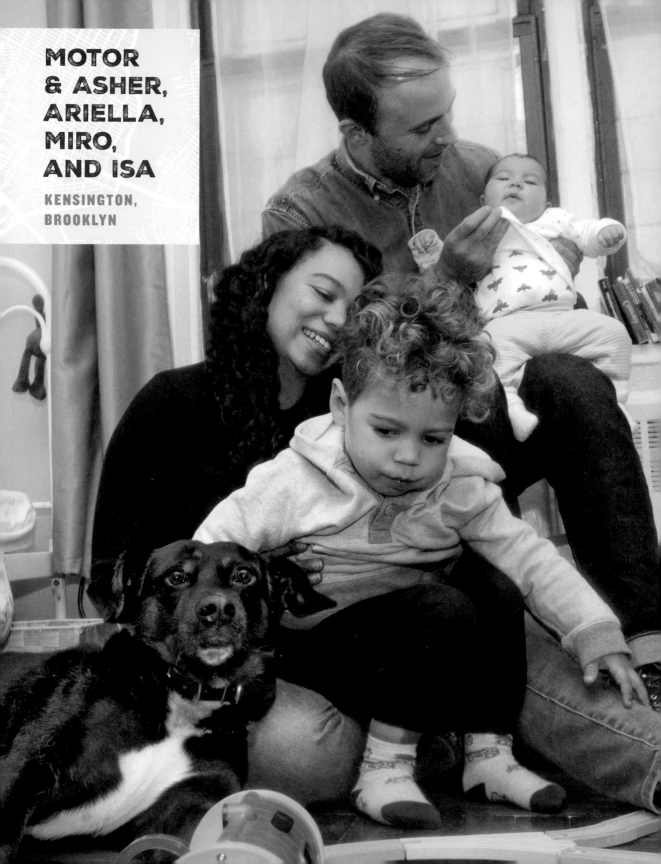

MOTOR
& ASHER,
ARIELLA,
MIRO,
AND ISA

KENSINGTON, BROOKLYN

Asher grew up with dogs, and as an adult he became a magnet for injured animals of all species: birds, possums, kittens, and, of course, dogs. He found Motor on a trip to Detroit. "He was skinny, a bit bloody, and pacing on the median across from Henry Ford Hospital," Asher remembers. But unlike so many of the other wayward animals that had passed through on their way to other homes, Motor stuck with him and then worked to assemble a family around him. At the end of Asher and Ariella's first date, Motor leaned in from the backseat of the car to give her a good-night kiss. "That's when I knew the date had gone well," Ariella says.

Motor has separation anxiety and always kept close to Asher's side, so it truly was a sign when, as Asher and Ariella's relationship grew more serious, Motor's loyalties transferred to Ariella. This was particularly true when she was pregnant with Miro and again with Isa. "After I got pregnant, he was glued to me," she says. "For both kids, he knew when I was approaching labor and wouldn't leave my side. He just stared into my eyes and whined, and that clued me in." During labor with Isa, the dog sitter texted, concerned that he had started howling at the door. They remembered he had done the same thing during Miro's birth, even though he wasn't present for either. "Motor licks their feet and nuzzles them when either of them cries," Asher adds.

They live in Kensington, Brooklyn, in what Asher jokingly refers to as "the last rent-stabilized apartment in the city." Bisected by Ocean Parkway, the two sides of the neighborhood are connected by overpasses and pedestrian bridges, which means there is easy access in and out, but some hiking involved if you're on foot. Asher moved to the neighborhood at eighteen, thinking it would be a temporary stop before graduating to more prominent areas of the city. But as the years passed and the family expanded, they found their options limited. Now, with children to consider, having Prospect Park just a few blocks away is a huge bonus, and amenities that were previously out of reach are moving closer.

"I got to know the neighborhood through Motor," Ariella says. "I moved here in 2014, but I really started to see it and explore it by walking him. Walking him I met way more people and talk to way more people. He's very well-known around here. He has his own agenda and dog and people friends. [The neighborhood] has a great mix of people, lots of families and a more close-knit feel than other places I have lived." As with anything in life, Motor's greatest qualities sometimes create problems of their own. "For instance, I can walk around places [and] feel safe and protected and not get harassed on the street. But his anxiety at being away from me or the babies makes it hard."

Motor may just love a little too much, but as problems go, in this or any other city, that's not a bad one to have.

ROCKET & SHIN

NOLITA, MANHATTAN

"I feel like a part of me is missing," Shin says. She has been through this before, but it never gets easier.

Shin had never been a dog person. She grew up downtown before the luxury boutiques moved in. As a teenager she made and sold T-shirts in the craft market next to Tower Records at 4th and Broadway. When the storefronts of the East Village were still barren, she opened her first shop at 9th and Avenue A. It was back in the days when people would live and work in the same space, and throw up a sign to let the neighbors know they were open for business. Her companion then was a cat named BooBoo.

But as the creative community thrived, rents increased. On a trip uptown to negotiate with her landlord, Shin spotted a doggie in a window. Literally. A dog named Pepper was up for adoption at a doggy day care. She convinced her brother to adopt him, but after a day, Pepper, a black chow mix, moved in with Shin and BooBoo. As Pepper and Shin walked the city she met a string of people who had all, at some point, adopted Pepper—and returned him for a variety of reasons, from allergies to his not getting along with another dog. At the shop, Pepper showed a natural talent as a salesman, greeting and playing briefly with each visitor and then giving them time to browse on their own.

To live in New York City for the long haul

requires an enormous tolerance for change and loss. Shin sold her store, moved to Miami—with BooBoo and Pepper—and then returned to Manhattan, finding an affordable place near the South Street Seaport. Together, they witnessed the terrorist attack of 9/11 and evacuated the dusty, debris-filled streets. When Shin decided to open a new shop in Chelsea, they moved closer so that the walk to work was more manageable for Pepper. When he passed, it was a devastating loss. "BooBoo had kept me in line and grounded me when I was crazy young," Shin says. "But Pepper *was* me. He lived through and saw me through so many changes. With every change and every move, he took it all in stride."

It took time. Shin looked at the pet adoption websites and considered some of the dogs but didn't pick up the phone until she saw Rocket, a seven-year-old chow mix who moved in with her in 2012.

He began his shop-dog career immediately. "The first customer who walked in, he greeted them at the door warmly and politely; there was no jumping, no over-the-top excitement. He schmoozed like a pro," Shin says. "Then he settled down and let them shop, and when they left, he lay there and just watched them leave."

They explored the West Village, Washington Square Park, Hudson River Park, and Chelsea. "In between dogs, I didn't get around much," Shin says. "The renovations that had been going [on] at Hudson River Park were mostly finished. There was a new Frank Gehry building on the West Side; so much development and construction was going on it was hard to keep track; the Whitney Museum was under construction. The city was morphing and changing at such a quick pace, or so it seemed. With Pepper and Rocket, they forced me to stop, enjoy, and see a lot of these changes."

In November 2016, Rocket had a stroke, but Shin helped him regain some of his strength. In 2017, increasing rents pushed them out again, this time to Nolita, a neighborhood Shin knew well from her high school days, when she and her friends would roam the Bowery and Canal Street. A vacant lot that she remembered had been turned into an unofficial neighborhood park: the Elizabeth Street Garden. This became Rocket's destination on his now-shortened walks. But like so much that is alive in the city, the gardens' days may be numbered: the city has plans to take back the lot and build housing.

Rocket passed away in January 2018. "He was thirteen; I had him for almost six years," Shin says. "Things are just not the same without him; he touched so many people in so many different ways; he made the store a welcoming personal space for people. He will be deeply missed. It also fills me with sadness to think that we may lose the garden as well. Like our relationships with our dogs, the garden is being nurtured by the community but in turn it nurtures and gives back so much more to all the people who come visit and enjoy it. This is how I feel about having my animals: I've gotten so much more in return."

MEGABYTE, CASSIE, AND RICKY & THE KERRS

KINGSBRIDGE, THE BRONX

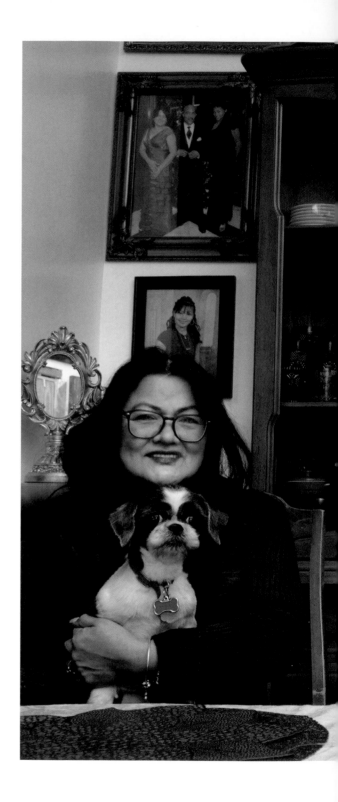

When George was younger, his Labradors used to ride the subway. On their own. His daughter, Kim, has heard the story a thousand times, how neighbors would tell him they saw his dogs on the subway while he was at work. He didn't believe them. His dogs were in the yard when he left; they were waiting when he got home. Then one day on the D train home, the subway doors opened up and they scampered on, confident until they spotted their master.

Kingsbridge is named for a bridge that was built in 1693 and is now believed to be buried under a section of Spuyten Duyvil Creek. Spuyten Duyvil means "spinning devil," and in the Kerrs' house, Ricky the Chihuahua is their own spuyten duyvil. But they love him anyway, because that's what family does. Ricky was handed to Annabelle one day because he had chewed too many of his owner's shoes. People give the Kerrs a lot of dogs because they know whatever happens, they will take care of them.

George can tell you all about the dogs, and all about the neighborhood. Down the street is the Kingsbridge Armory, thought to be the largest armory in the world, covering nearly

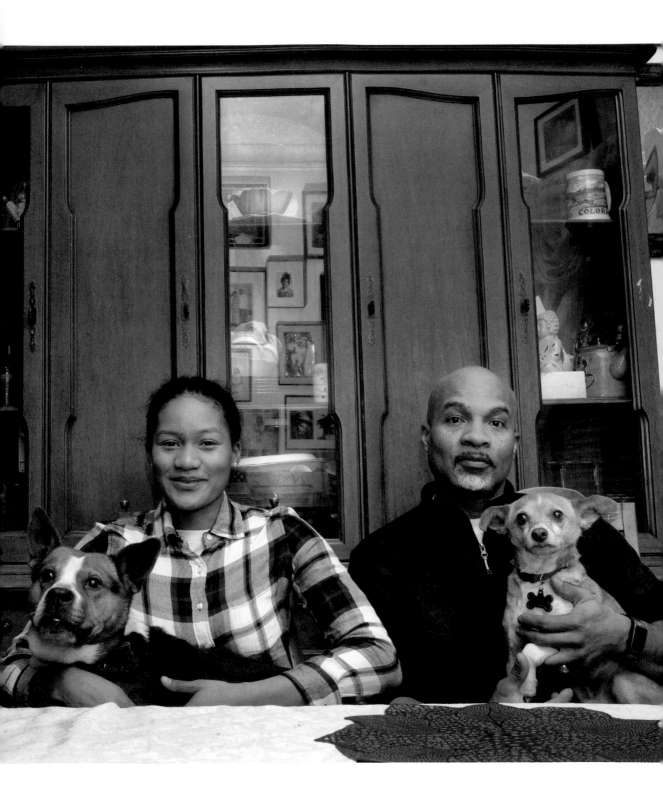

five acres, surrounded by a moat, and topped with spired towers and a massive copper and iron roof.

The Kerrs' home is one of two freestanding houses on the block, surrounded by massive apartment buildings that remind passersby how lucky it is to have your own house. George works from home doing IT stuff; his wife, Annabelle, and daughter, Kim are schoolteachers. In a corner in the first-floor parlor is a display case filled with Annabelle's collection of international Barbies, wearing traditional costumes from their country of origin. She uses these in her classroom but doesn't know when some of the Barbies traded clothes. The dining room walls are covered with framed photos. George started on one side with his ancestors, and his wife started on the opposite side with hers. On the two remaining walls are photographs of the family they have raised together, including their two children, from baby to high school to young adult.

Though the photos highlight the human family members, their pets have always been central. Cassie, the Shih Tzu, was initially so fragile that Annabelle tucked her into her shirt to keep her close at all times. Megabyte, like his namesake, stores a wealth of family memories. One year, with a few absent spots at the Thanksgiving table, they invited the dogs to sit with them.

George sometimes pretends he's had enough of the dogs. He might even pretend to wonder when the kids will move out. But no one is leaving. "Why would I want them to move out?" Annabelle asks. "They're the only children I have."

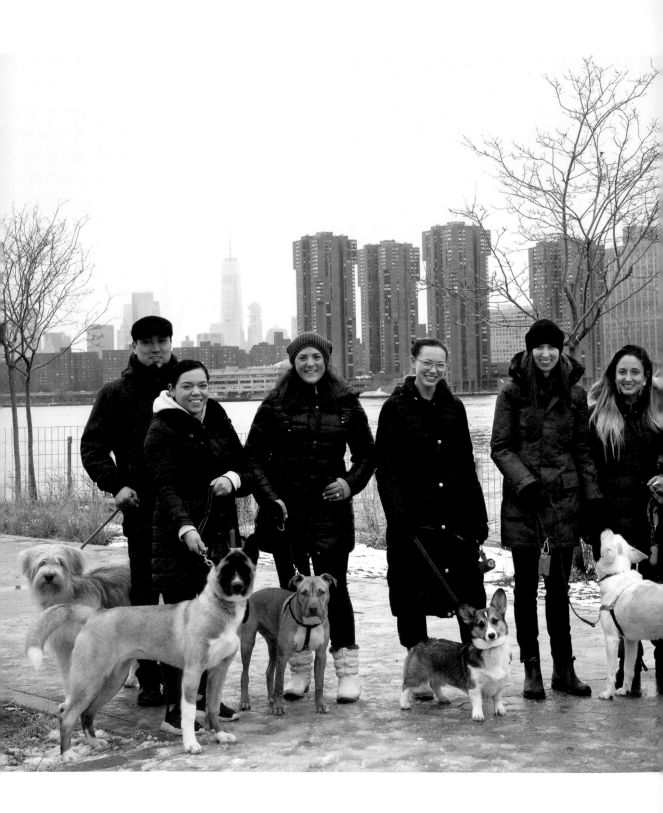

THE DOGS OF HUNTERS POINT

LONG ISLAND CITY, QUEENS

"Every morning, Charlie and I go to the grass area by the waterfront and he runs around with his pals," Amy says. Charlie is her pit bull puppy, adopted last year, or, really, a foster failure. After the death of her previous dog, Amy and her husband weren't sure they were ready for another, but they agreed to take Charlie temporarily, and he never left. "The same dogs and the same owners have made this part of their daily ritual. All the dogs know one another, get along and love to play together. The humans have gotten to know one another." And they've all probably picked up habits from one another, for better or worse.

Long Island City and Hunters Point sit at the western end of Long Island, in the borough of Queens. This creates a lot of confusion among people who don't realize that Long Island overlaps geographically with Brooklyn and Queens. Because of its waterfront access, the area was historically populated with warehouses and other signs of industry but now has one of the most rapidly growing residential populations and the highest proportion of art galleries and studios in all five boroughs.

Nicole adopted Hayley after battling some health issues. "Having a dog helped me get out and walk even when it wasn't comfortable to

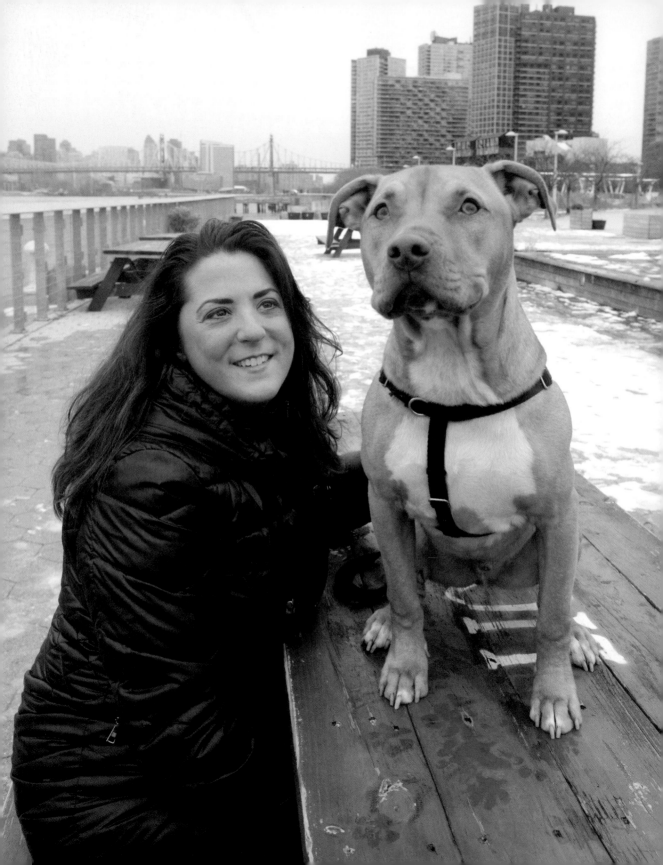

do so," she says. "It also meant that I had to get out of my head and focus on the training and care of my new pet. I've had old couples ask me about her breed. I've had toddlers run up to hug her. One time I noticed a gang of teen boys following me. I thought I was going to be mugged, but they asked if it was okay to pet my dog. Two weeks after getting Hayley, and I couldn't walk down the street without chatting with friends and learning about neighborhood gossip."

Walking the dogs as a group or supervising their play in the dog run, these neighbors have developed unlikely friendships, watching out for one another's pups, and watching out for one another. "This is the best way I have come to know my neighbors," Vicky says. "People from all sorts of backgrounds that I would probably never know except for our love of our dogs."

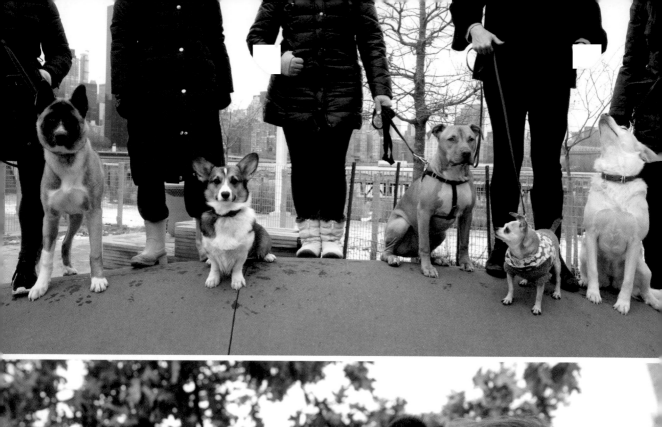
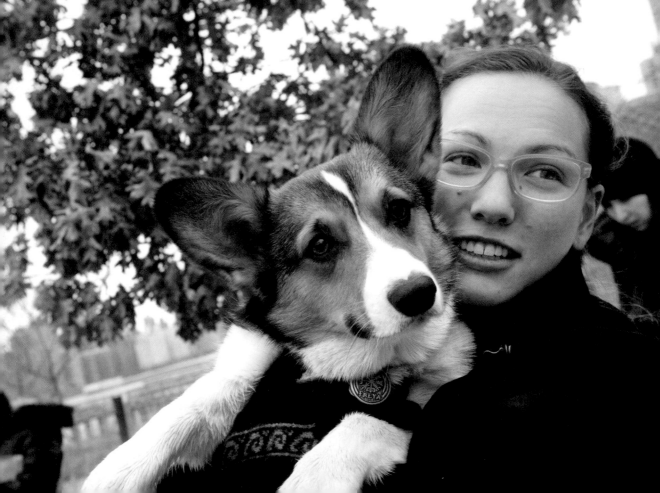

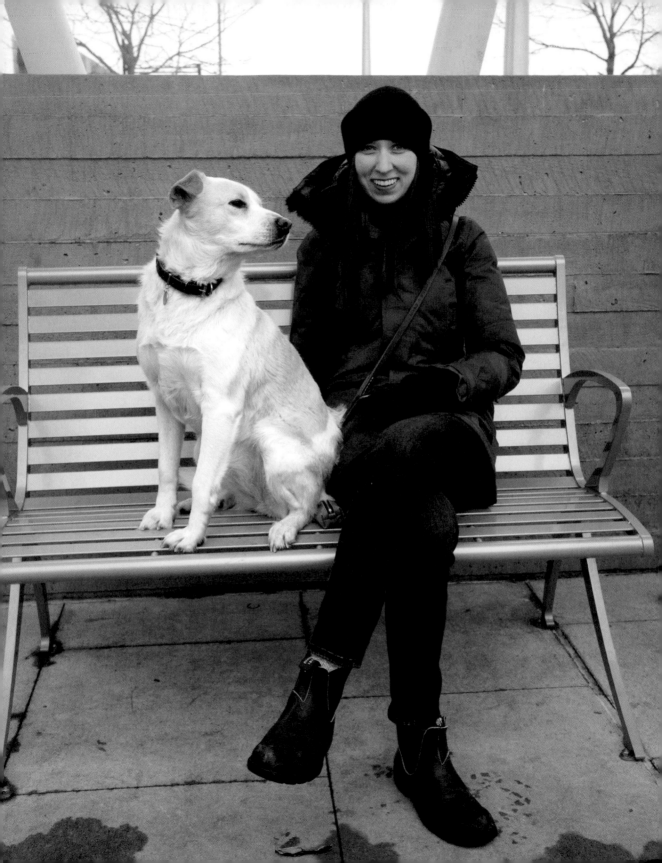

ROCCO AND JUNIOR & JIM

MORNINGSIDE HEIGHTS, MANHATTAN

Junior enjoys the city; Rocco prefers the country. Fortunately for them, Jim splits his time between both. An accountant by training and trade, Jim now doubles as a travel coordinator for his two dogs. Rocco, the nine-year-old terrier, was thrilled when Jim decided to move to the country, where life was quieter and he could indulge his terrier activities of chasing rabbits, chipmunks, and squirrels and digging large holes in the garden. While Rocco demonstrates all the stereotypes of his breed, his younger brother, Junior, demonstrates that DNA doesn't always dictate behavior. Junior is a service-dog dropout. He was bred to be a guide dog and trained with Guiding Eyes for the Blind. But it didn't work out. He is extremely smell sensitive. There are unconfirmed rumors that he may have stolen food from the blind. To put it more diplomatically, it simply wasn't his calling. Jim adopted him, and now Rocco is showing him how to be a regular dog. Jim jokes that they are deprogramming him.

"Junior prefers the city life: meeting various people and dogs in Morningside Park and taking in all the smells of the city," Jim says. "Both dogs enjoy the Metro North train ride into Harlem and the walk along 125th Street to Riverside Park and the Columbia University campus. My dogs are more confident, funny, and charming than their owner. They are willing to perform tricks, such as lie down, paw, and roll over for any pretty lady or in front of a café to get admiration and kisses—but their main goal is really food. We live in a walk-up that is dog-friendly, so the neighbors are welcoming and willing to house-sit the dogs. I make sure the dogs get plenty of exercise in the morning, so they sleep during the day and won't disturb the neighbors."

Though Rocco favors the country, his years in Manhattan have given him the street smarts that Junior still lacks. Really, Rocco is the boss of both Junior and Jim. "In general, working in New York City is very stressful and exhausting," Jim says, "but the dogs make you take the time for long walks, strolling down different streets, meeting other dog owners in parks, and just relaxing and enjoying life."

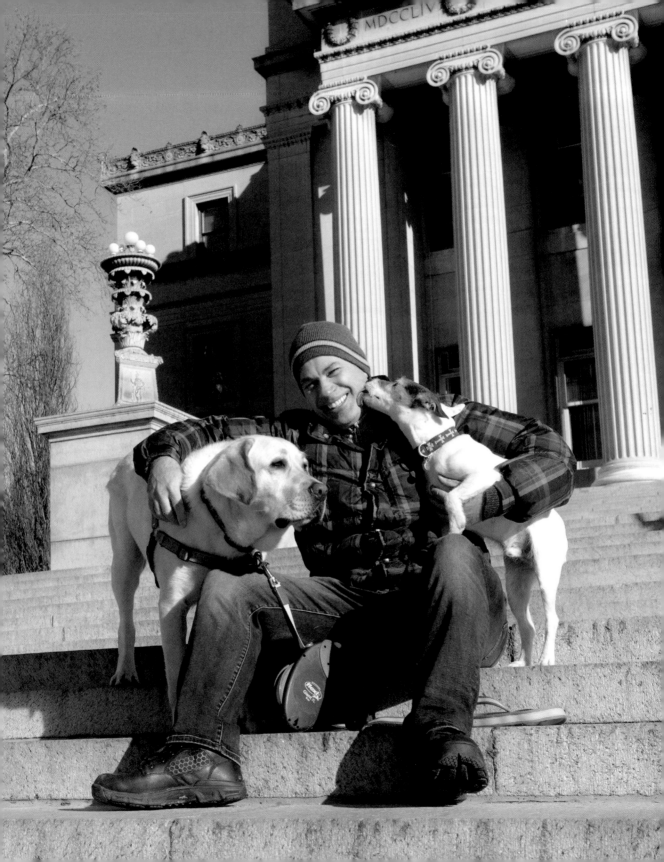

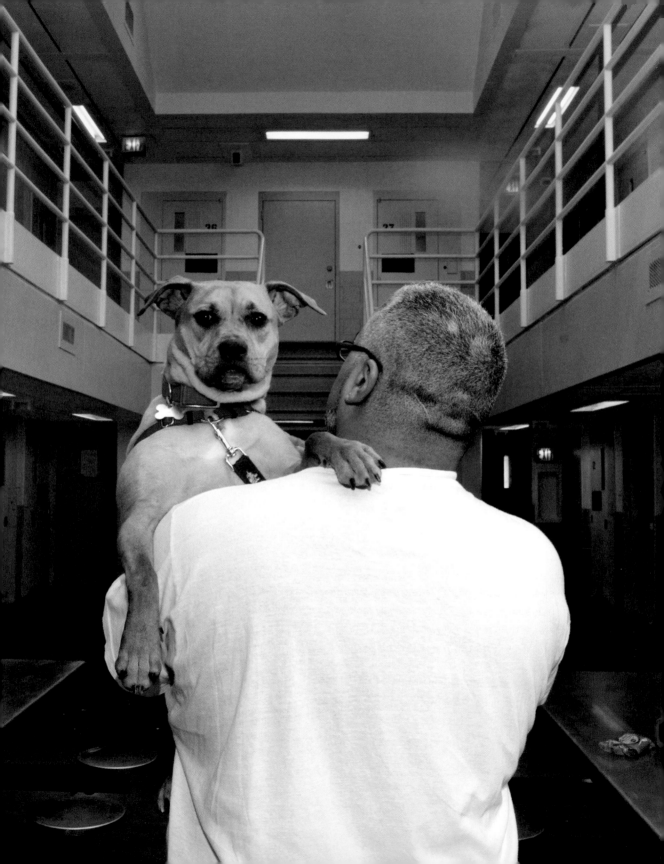

BATMAN, LYDIA, EVETTE, AND OHANA & THE MEN OF THE GEORGE R. VIERNO CENTER

RIKERS ISLAND, THE BRONX AND QUEENS

Evette came from rural Georgia. Batman was a stray in Nashville. Ohana was at the shelter in Yonkers. Lydia was running loose in Poughkeepsie. And then they came together for eight weeks in the PAWS of Purpose program at Rikers.

Rikers is a literal limbo. The inmates are waiting for their cases to be resolved in the court system; it sometimes takes years. It can feel as if time stands still there, though they know that in the world they left behind, things are moving on without them. Their families are getting older, their children are growing, and their dogs are waiting for them to come home. Even geographically, Rikers shouldn't really exist: an island built from ash in the water between three boroughs, it is politically represented by the Bronx but shares a zip code with Queens. It is a transitional space for the dogs, too, although unlike their human friends here, they are guaranteed to end up in a better place once their time is done.

Even if you haven't spent much time in a prison, you can tell that this cell block is unusually quiet. The sense of calm comes from the sense of purpose the men share in caring for the dogs. Although there are forty cells, only twenty men are assigned here. In teams

of five, they work together caring for and training one of the dogs. At night, the dogs sleep in the cell with their primary caregiver. The results, for the dogs and the men, are clear: Evette was shy and fearful of strangers when she first arrived, but after just a few weeks, she became the first to greet any visitor, scampering around the communal tables and play-bowing for attention. The men, some of whom had good reason to keep to themselves, help each other accomplish the tasks of caring for their pups and don't hesitate to show off the progress they've made with tricks and commands. In addition to Evette's transition to hostess, Batman is so adept at interactions with people that he's begun making regular visits to the patients at the island's mental health facility. Ohana, a gentle sweetheart, still prefers staying close to his primary, and the two of them are often to the side of the action, cuddling each other. (Lydia, though she means well, will prove herself to be a bit too rambunctious and "graduate" early.)

At the end of the eight weeks, it's painful to watch the dogs go. Everyone gathers in the gymnasium for a ceremony. The men are there with the dogs, of course. But so are their families, and the corrections officers

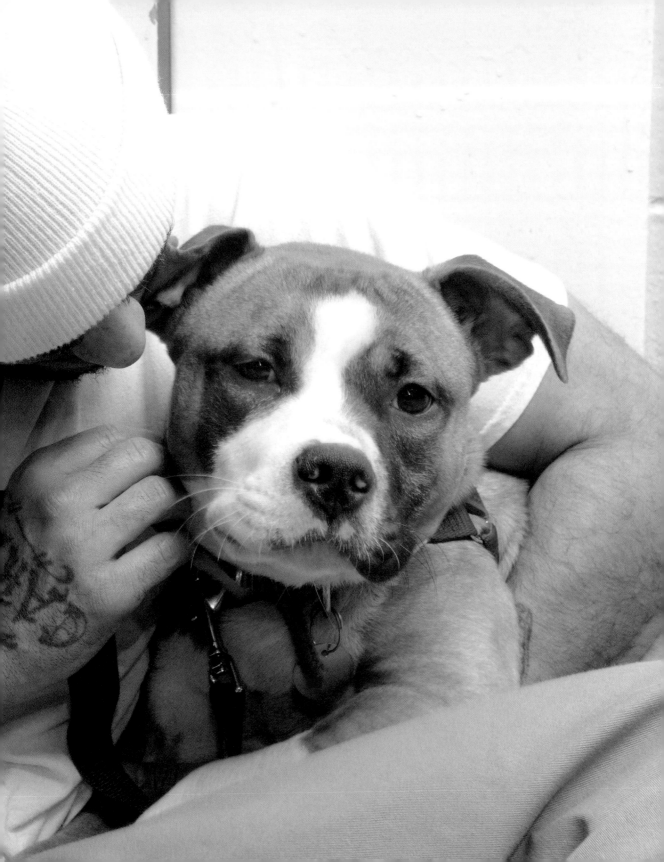

who help facilitate the program. Representatives from Animal Farm Foundation, which helps select the dogs and supplies resources, are seated in the first row. The dogs and their teams are called up to the podium to demonstrate their new tricks. Some will go on to train as service dogs; others will be adopted into homes. The men make speeches about how much the program has meant to them. CO Fitzpatrick also speaks. "Paws of Purpose is special because it allows DOC correction officers to break through barriers and push aside differences with individuals in our custody to work together for the greater good," he says. "Paws of Purpose is special because it helps everyone to shed their tough exteriors, let down their guard, in order to show love and compassion in a place that is normally absent of such feelings."

Then lunch is served, and men and dogs get to spend time with the families and girlfriends who have come to visit. Ohana's handler doesn't have any family here, so the two of them leave the lunch tables and sit together, alone, on the empty bleachers on the other side of the gym. When the signal is given, it is time for the visitors and the dogs to leave the inmates behind. The staff from Animal Farm Foundation gather up the dogs and are escorted down the halls and through the series of locked security gates, past the metal detectors, out into the parking lot. At each gate, the dogs' excitement grows. They pile onto laps in the car, pass over the bridge that connects the island to Queens, and they are free.

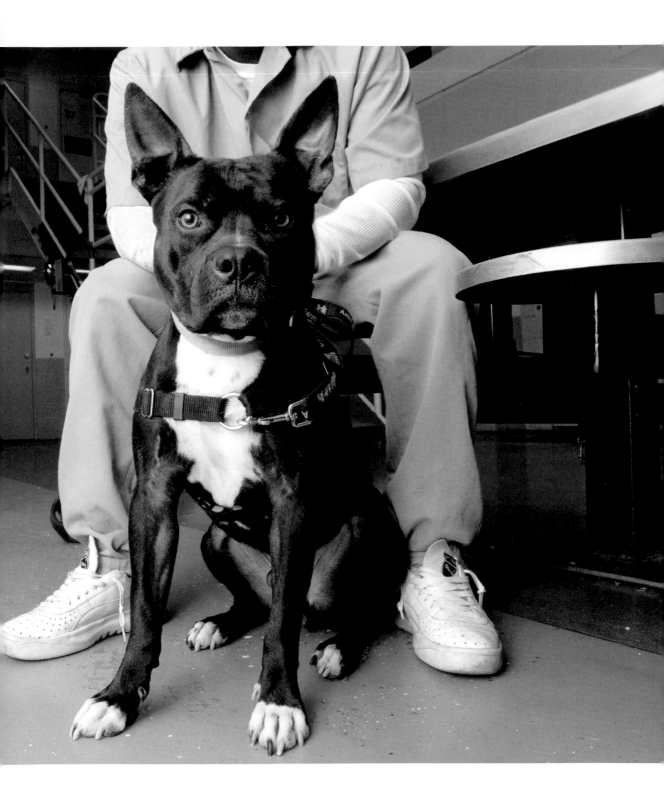

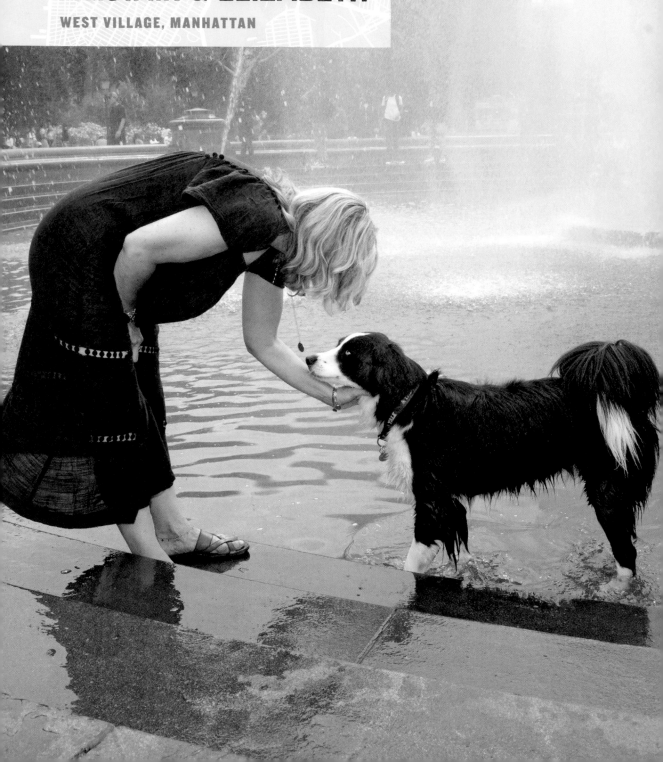

Elizabeth Wurtzel is famous—some might say notorious—for her honest and raw memoirs, including *Prozac Nation*, but when she walks the streets of Greenwich Village, it is her dog who is the star. This is completely fine with Elizabeth. In fact, it was what she hoped for. Her previous dog, Augusta, was a star as well. "Before Augusta, I did not know I could love that much," she says. "Augusta stunned me when she had to say hello to every person at every table at every outdoor café as we walked along. She thought she was a movie star. She would stop and wait to be noticed. She wanted people to pet her and say she was gorgeous. She was an insanely extroverted dog. I admired her moxie."

Elizabeth's apartment manages to be simultaneously spacious and cluttered, in the best possible way. Every object tells part of the story of how she got to this moment. There are lots of books. There are also framed photos of herself that were the covers of her books: a pensive outtake from the shoot for *Prozac Nation* and topless for *Bitch*, her celebration of difficult women. She even has the peculiar *New York Times* marriage announcement on display: "Elizabeth Wurtzel Finds Someone to Love Her." But the most important thing is Alistair, and he's never more than an arm's length away.

A walk to Washington Square confirms Alistair's status: you know you live among dog people when the folks on the street first make eye contact with and say hello to your dog before, perhaps, raising their gaze to greet you, too. Once they have passed through the arch, Alistair takes a quick dip in the fountain and Elizabeth follows. A crowd of tourists circles, phones outstretched, not for a moment considering that what they are doing might be a bit odd, because Alistair is a mesmerizing presence. On the way back home, there's a stop in a tiny espresso bar, where Alistair suddenly seems enormous, and after some polite conversation his admirers notice that Elizabeth is there, too.

Elizabeth didn't think she was ready. She had been sitting in a coffee shop following radiation treatment for breast cancer, and remembering her dog Augusta. People thought breast cancer was bad, but for Elizabeth, the death of her dog was more traumatizing. But maybe it was time to just begin to look, she thought. She had found Augusta at a city shelter, so she pulled up their website and saw that there was another border collie mix at the Brooklyn branch. She didn't even know where the Brooklyn shelter was, but she called a car.

"We named him Alistair," she says. "It is a ridiculous name for a dog. It is a ridiculous name for a person." At first she tried to resist his charms. It didn't work. "I think it's love," she says. "It must be love."

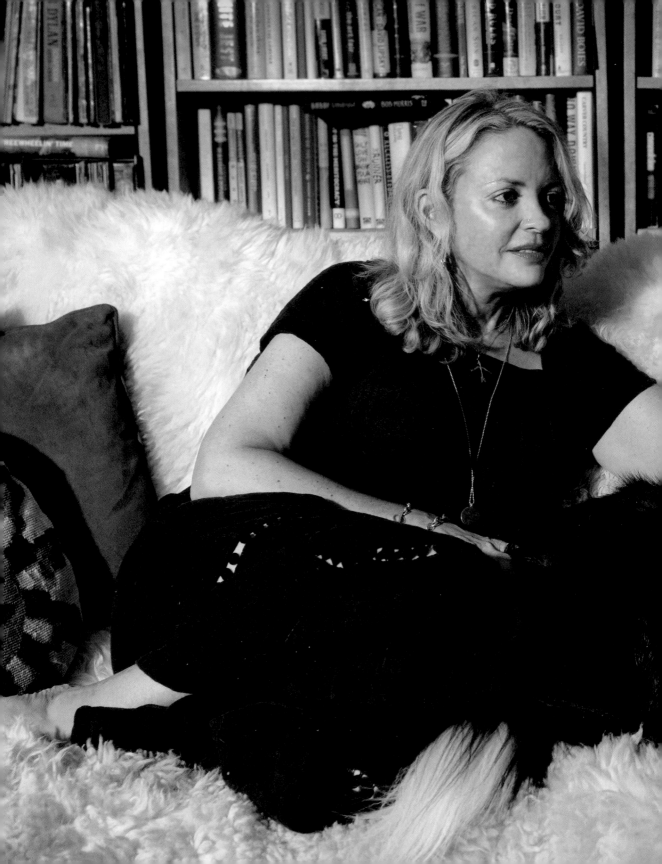

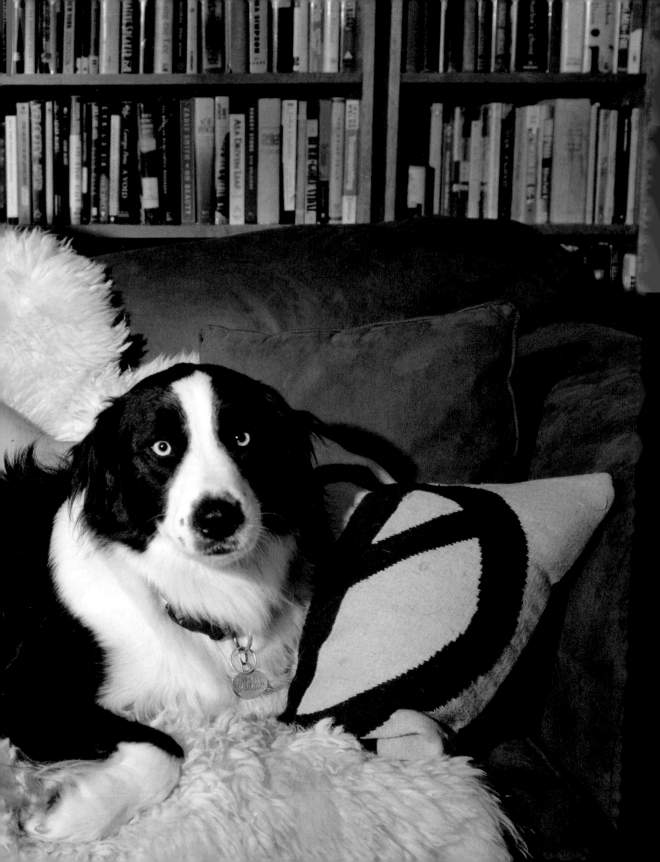

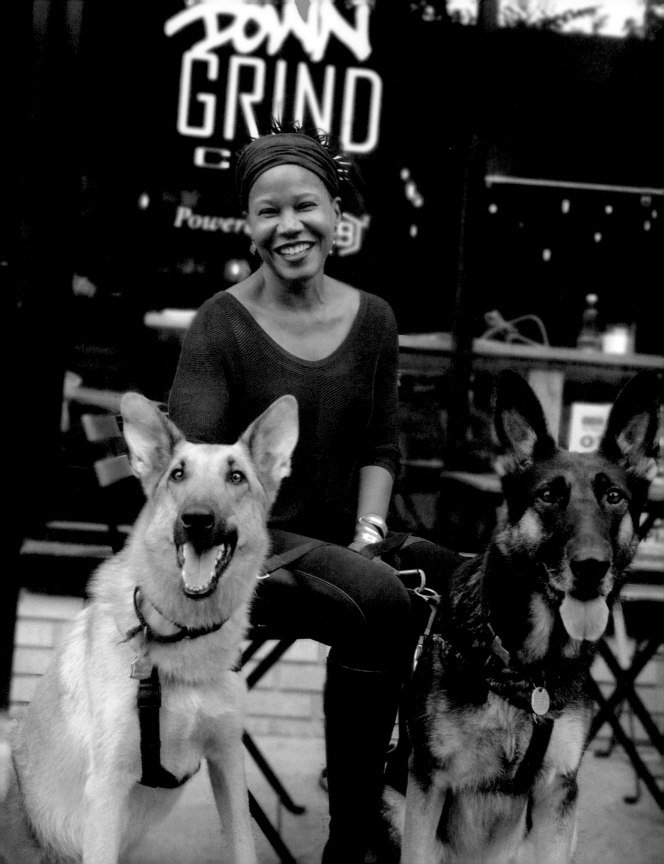

MONKEY AND KHALEESI & MAJORA

HUNTS POINT, THE BRONX

Hunts Point is defined by two things: its strong sense of community and its geographic isolation. Surrounded by water on three sides and cut off from the rest of the Bronx by a range of elevated highways that can be crossed but rarely are, Hunts Point's residential blocks are surrounded by waterfront warehouses and the sense that somewhere, beyond them, is a stunning view. If you live in Hunts Point, you know everyone else who lives in Hunts Point, and you know their dogs. The network of dog-loving neighbors is so strong that animals here rarely end up in the city shelter; instead, they move down the street to another home. Murals decorate the sides of buildings and fences, celebrating local residents and their contributions. If you are Majora Carter, you might even find yourself walking your dogs past a mural of yourself and laughing at the reassuring knowledge that they are not so easily impressed.

Majora often begins by talking about her dog. Even her TED Talk, "Regreening the Ghetto," one of the first in that series, starts there. "The reason I'm here today . . . is because of a dog," she said. "An abandoned puppy I found in the rain back in 1998 . . . When she came into my life we were fighting against a huge waste facility planned for the East River Waterfront." She'd lived in Hunts Point her entire life, but it was impossible to walk to the river because of all the industrial facilities blocking resident access. "One day, while jogging, she pulled me into what I thought was just another illegal dump." The dog kept dragging her through the weeds and garbage until they reached the end of the lot at the river. Majora had an epiphany: she and her formerly abandoned dog would bring this abandoned lot back into use by the people. "Just like my new dog, it was an idea that got bigger than I imagined."

That dog was Xena, and when Majora first met her, it wasn't the right time to bring a dog into her life. In addition to her community-driven work, she was helping her family care for their ailing father. But Xena stayed, and, among the many other benefits, Majora discovered that she felt safer as a single woman exploring the city with a large dog at her side. Starting with $10,000 in seed money, that abandoned dumping ground received a $3 million renovation. And Xena was the flower girl when Majora married her husband, James, on that very spot.

After Xena passed away, James found himself scanning the Internet looking tentatively (but obsessively) for a new companion. They ended up with two. At first he found that the rescue databases seemed to be connecting

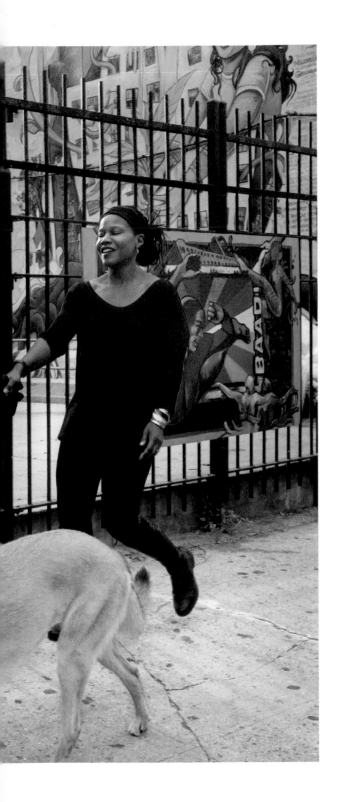

him with shady operators who listed adult dogs but tried to sell him purebred puppies, but one morning a German shepherd came up in a shelter just north of the city. He immediately drove up, and although she wasn't officially available for adoption, he put the money down right away. While her health cleared up, James and Majora visited every day, so by the time they brought Monkey home, they were already a family.

She was also a handful. So he began searching again and found a shepherd puppy that had been left behind at a grooming salon in Harrisburg, Pennsylvania. The videos they watched online convinced them that the time was right to bring her home. Because they love *Game of Thrones*, and she's blond, they named her Khaleesi. But James says, "She's not a powerful liberator of slaves."

"The older generation misses German shepherds," he says of the neighborhood. There used to be more of them, but now the population seems mostly pit bulls and Chihuahuas, so Monkey and Khaleesi have a lot of fans. They've also shown James and Majora something new about the neighborhood: "There are a surprising number of wild rabbits here." The rabbits, it is safe to say, are not among their fans.

TEQUILA & RICKY AND OLGA

EAST HARLEM, MANHATTAN

It's about 2:00 p.m. when Ricky walks into Dear Mama for his first coffee of the day. This isn't an after-lunch aperitif or teatime; for Ricky and Tequila, the Yorkie in the palm of his hand, it may as well be sunrise. Ricky works in nightlife, so his schedule is flipped around, or, from his point of view, it is the rest of us who have things out of order. Nine-month-old Tequila follows his lead. She was originally a gift for Olga, Ricky's girlfriend, who grew up with a dog in Latvia and whose schedule is irregular as well: she's a model.

The three of them live in a new building on East 109th Street, where they blend in pretty well on this diverse block. Zach, the owner of the café, says the dogs on the street make up the vibe as much as their owners. "We have Christian, a born-and-raised New Yorker and his rescue pit, Brooklyn, who visits us daily with her ferocious tail wag and sweater vest. Then we have the gorgeous husky Kai, who belongs to Eamon and Nicole, with her gorgeous blue eyes and insistent vocal declaration for petting. And there's Franky, the handyman, who grew up on the block and can be found with his Pomeranian/Chihuahua at his side."

But Ricky, Tequila, and Olga may be the most distinctive family on the block. Olga is as tall as Tequila is petite. Ricky never had a dog before. "It makes us come home earlier than we usually do," he says. "If not for the dog we'd stay out later, whether it's daytime or nighttime, and be totally carefree." But that doesn't mean they are homebodies. On Instagram one can see evidence of Tequila's jet-set lifestyle, popping up at beach parties in LA, and while Olga may be off on assignment in Germany, she checks in on the boys back home. Ricky posts a picture of Tequila, freshly groomed and bandanna'd and working the camera like his momma taught him well. "Our baby!" Olga comments, and even from this distance a reader knows it won't be long before she's home.

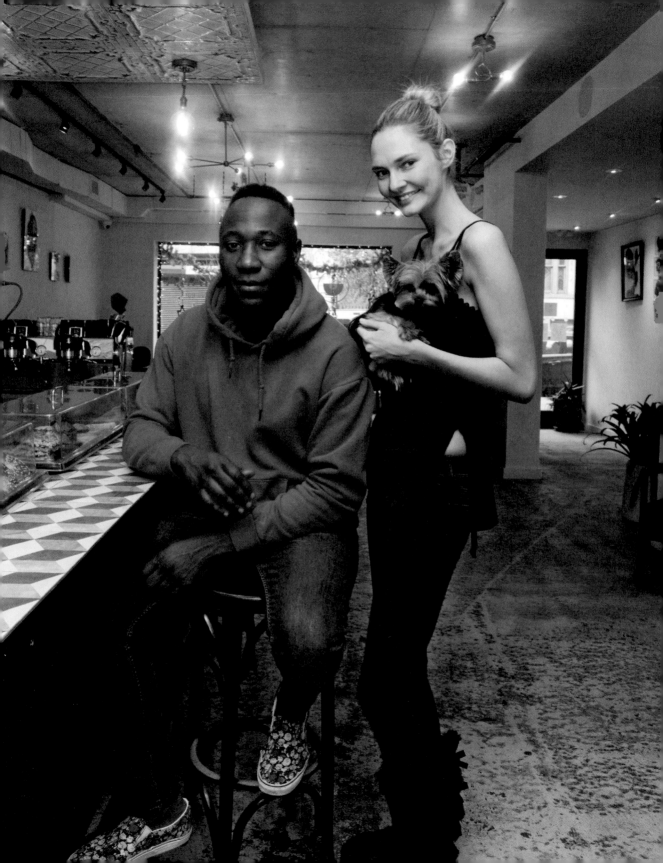

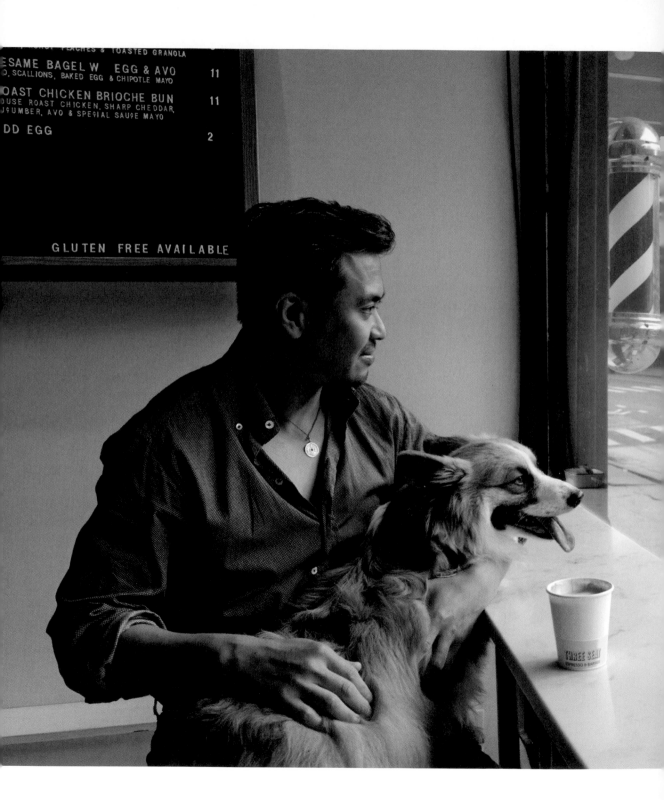

HOBBES & WILL

EAST VILLAGE, MANHATTAN

Hobbes is at the center of a corgi renaissance in the East Village, although he's too caught up in the moment to be self-aware. Can a dog be called gregarious? If so, then Hobbes certainly qualifies. There he is at Three Seat Espresso, holding Will securely to his stool while they gaze out at Tompkins Square. Or maybe you'd spot them in the evening at d.b.a. Hobbes loves to pop his head into Lovemore & Do to check on the people who groom Will, too.

Dog parks are such an essential part of life in the five boroughs that it is hard to imagine there was a time when they didn't exist. The first public dog park in New York City opened in Tompkins Square Park in 1990. At the time, the storefronts nearby were mostly vacant; the city wasn't healthy. There was crime and drug trade, and both tended to be found in neighborhoods off to the side of things. After the dog park opened, the city realized that people wanted to live where their dogs could play freely, and the new dog and pedestrian traffic pushed crime out. Now there are more than 150 dog parks in the city.

Another side effect is an increase in dog envy. People gather around the fringe of the park to watch the happier people inside, interacting and building community. Will was one of those people until he finally got Hobbes. "Don't tell Hobbes," Will says, "I actually wanted a husky at first." But a friend kept

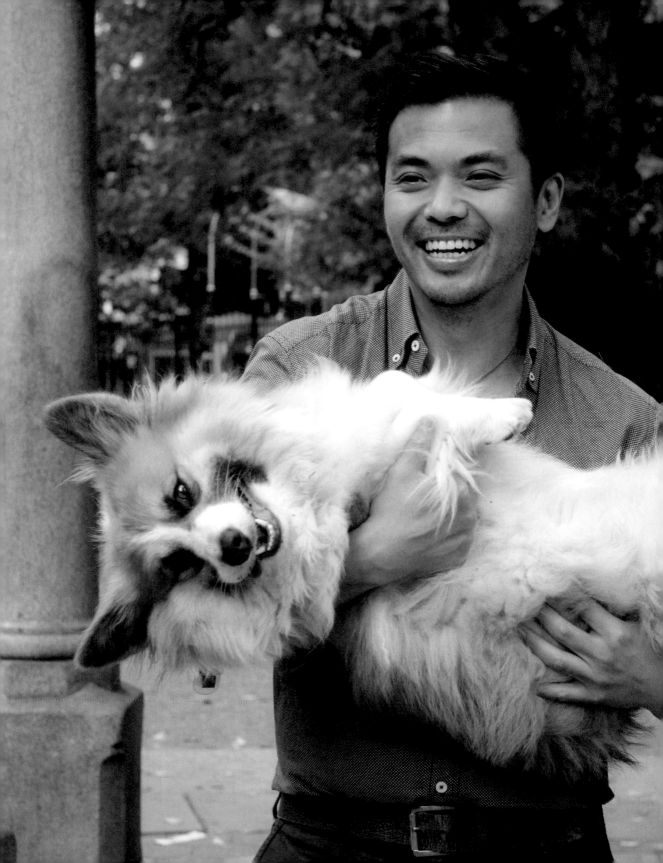

sending corgi memes, which inspired Will to investigate the breed. After a night down a rabbit hole of Internet research, he found a pet store where he could interact with them directly and then found a more responsible source for acquiring his first dog.

Because he didn't grow up with pets, his family was skeptical. What about his career? What about his social life? Now Will's parents call more often—to catch up with Hobbes.

"Hobbes surprised me on how similar we are," Will says. "We're both optimistic and generally content and happy with life, if you want to call it that. I'm quite surprised about his lack of fear, especially when he gets in trouble with bigger dogs. That too is similar between him and me. If there's one personality trait that defines us both, it's that we are guardian-like. We have this innate quality to fiercely protect the ones we love.

"I wake up a little earlier these days to walk him. I leave work a little earlier so I can be with him more. I spend more time wandering aimlessly around the city now. My priorities in life have shifted a little—he has become someone who's important in my life, a sense of unconditional love. In some ways he motivates me. I spend my nights improving myself professionally with online classes. My hope is that I can make a better life for both Hobbes and me. "

BAKER & THE VINCENTS

WASHINGTON HEIGHTS, MANHATTAN

People sometimes forget that there are neighborhoods in Manhattan north of Times Square, north of the Upper West Side, north of Harlem. Washington Heights is the highest point in Manhattan, though after World War II it was called Frankfurt-on-the-Hudson because of the number of German Jews immigrating to safety there. Of course, immigrants populate the history of every New York neighborhood, just as they populate the history of the United States itself. Today, Washington Heights is home to many Dominicans, and at least one dog who is a refugee from Spain.

Aspen and Tony Vincent didn't intend to adopt a dog from another country, but after trying to go through local rescue organizations and getting the runaround, they found that it was easier to adopt from Spain. They know that's a little bit crazy. But it meant that Baker, a Galgo Español, got a great home.

Aspen and Tony are musical theater actors who met in Las Vegas and moved to New York together. Tony continues to work in shows like *Rent*, *Jesus Christ Superstar*, and *American Idiot*, while Aspen has focused more on voice work for animated shows since the birth of their daughter, Sadie. That means Sadie and Baker almost always have at least one of their parents at home.

They were surprised at what a homebody Baker turned out to be, and when Aspen became pregnant with their second child shortly after he arrived, he didn't want her out of his sight. The Vincents' home is a classic Washington Heights apartment, with a sprawling common living and dining room with bedrooms off to the side. Baker prefers a corner of their bedroom. Burrowing suits him, visually, since he has the appearance of a shy kangaroo.

"He was absolutely terrified of everything here for a while," Aspen recalls. "The city scared him to death. He didn't play with toys and wanted nothing to do with us. He had never been on an elevator or a flight of stairs. Didn't know how to walk through a lobby door on-leash. Had never slept in a room with humans. Absolutely everything was new. So we took it slow. Really slow." But as Aspen's pregnancy has progressed, Baker has grown more confident. "He runs over to us when we get the leash out, plays with his toys all day, goofs around with Sadie, roughhouses with Tony, and walks like a champ on-leash."

Each night, the family gathers in Sadie's room for story time. Aspen is the reader, while Tony and Sadie listen, rapt, with Baker at their feet.

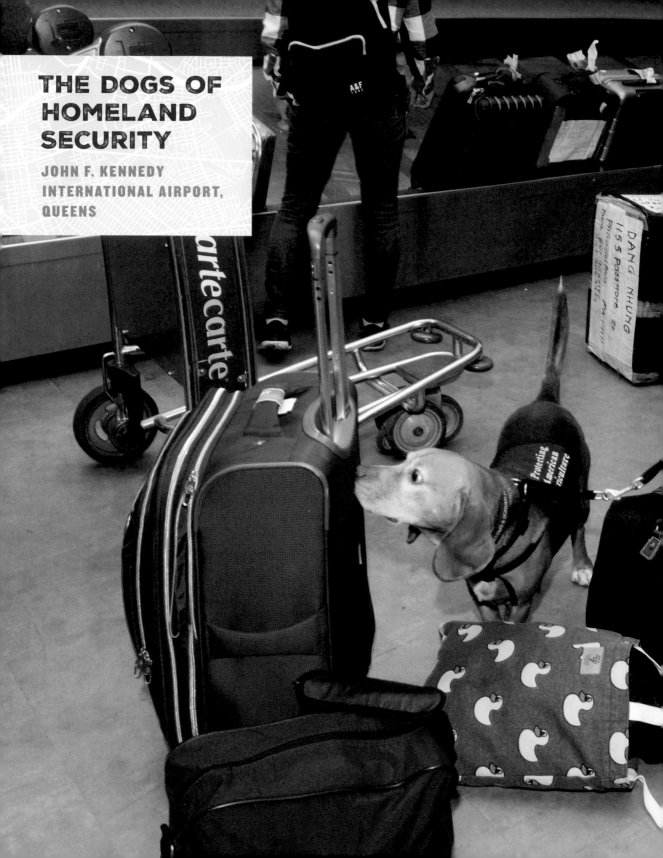

THE DOGS OF HOMELAND SECURITY

JOHN F. KENNEDY INTERNATIONAL AIRPORT, QUEENS

It's all about the smells! Vacuum-packed chicken-claw snacks. Beef-flavored candy. Mysterious mushrooms. A Maeve Binchy novel filled with brand-name marijuana. Freeze-dried sea horses. A spittle-based bird's nest for making stew.

Behind the scenes at John F. Kennedy International Airport, there's a whole team of dogs working to protect the security of passengers as well as the citizens and the environment. It may sound dramatic, but these dogs play it cool. Trained from a young age to signal in response to specific scents, the dogs fan out with their handlers through the airport, working eight-hour shifts before returning to their on-site kennels for a satisfying rest. Don't feel sorry for these working dogs; for them, work is play and they love the game.

In baggage claim, a beagle and his handler walk among the passengers who are eagerly waiting for their belongings to appear. As the suitcases and trunks are stacked onto a Smarte Carte, the dog takes a discreet sniff. In most cases, the interaction begins and ends there, but if the dog picks up on contraband, he will gaze up at the passenger, and his human officer will politely request that they pop open their case. Most often, what they've discovered is agricultural and unintentional: a snack that poses some risk of contamination to the US agricultural system. The danger isn't from the food or plant itself but from potential parasites it could be carrying. Sometimes the dog is triggered by smoked cheese, which isn't banned but smells similar to forbidden meats.

Behind the scenes, a Malinois is walking the conveyor belt, checking on luggage that is being sorted for different flights. He

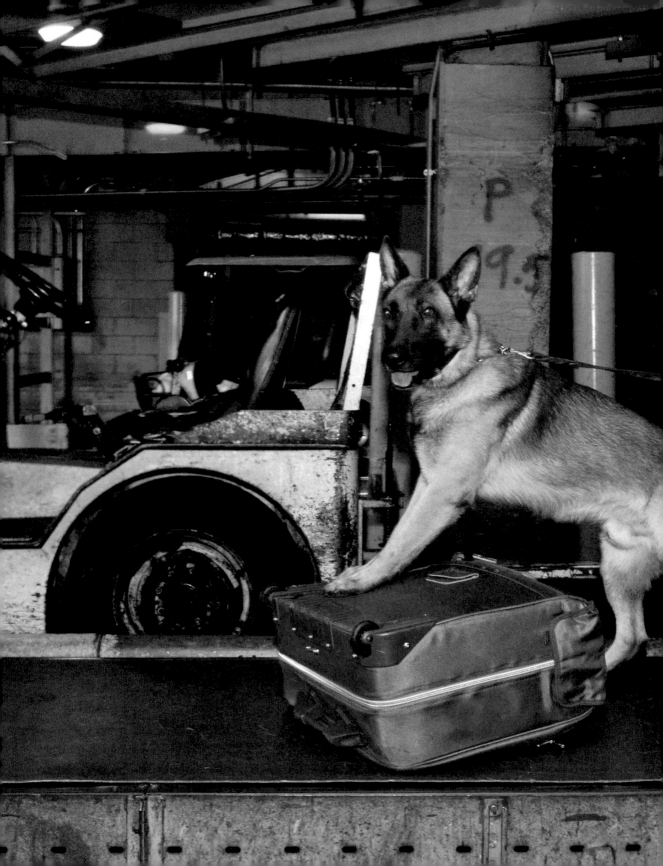

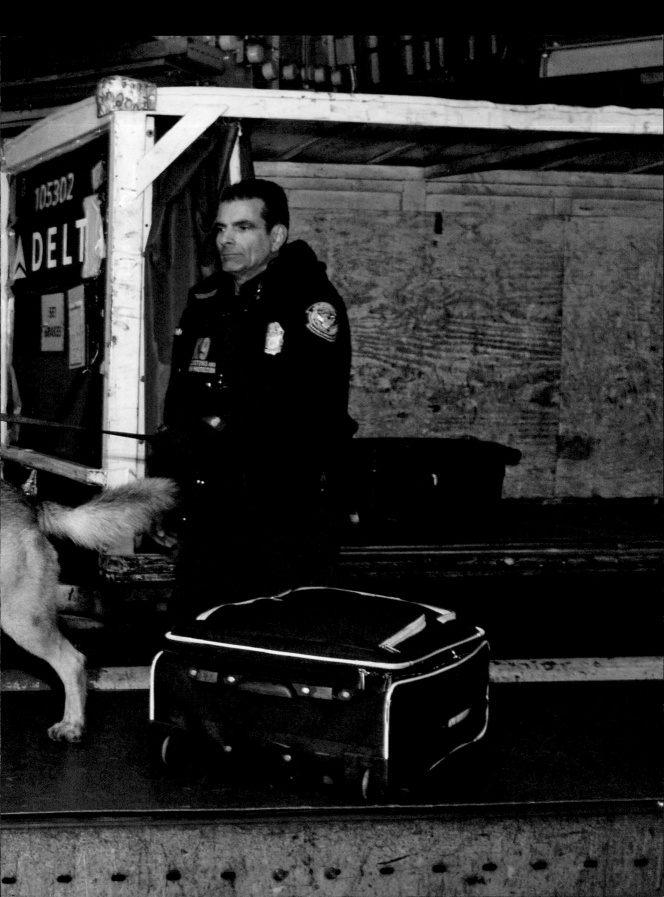

paces efficiently around and over each piece as it passes, until something draws his attention and he sits until a handler pulls the bag. With each find, he gets a reward—a moment with his favorite toy—and then back to work. To keep things fun, and to make sure there are always successes in the long day, the team occasionally tosses an intentionally scented package into the mix. In the mail hangar, the dog correctly recognizes a cardboard box that smells like fentanyl. Then, toy! And back to work.

Passengers are scent-screened as well, although it is done so discreetly they may not even realize it is happening. An officer walks his dog past passengers lined up to board along a narrow passageway, until the dog abruptly sits in front of a middle-aged man. He turns out to be a plant: a journalist intentionally dressed with a vest emitting a crack-cocaine scent. All the dogs care about is getting the right answer.

Having a canine partner is an honor here. Being the human half of the team requires as much focus and training as it does to be the dog. It's like ballroom dancing: you get used to the nuance of your partner, so it's no wonder the dogs, when they retire, almost always go home with their handler or another member of the human team. When they are on duty, these dogs are the city's gatekeepers, keeping track of arrivals and departures and making sure everyone gets safely home.

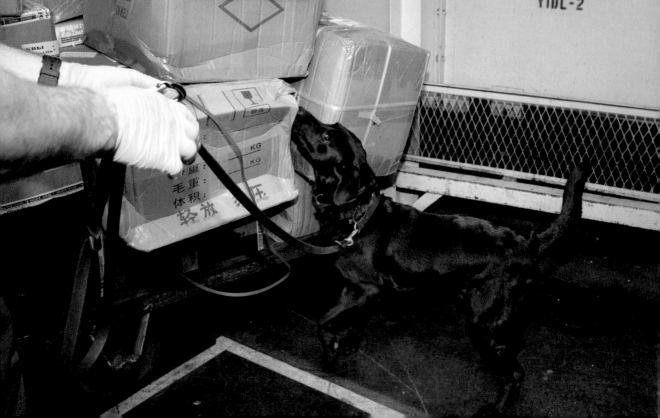

SADIE & DR. ALEX

CHELSEA, MANHATTAN

The High Line is an abandoned elevated train track that runs from the West Village, below 14th Street, through Chelsea, to the Hudson Yards at West 34th Street. It was converted in 2009 into an elevated park, instantly raising the value of neighborhood properties to levels only real estate agents could have dreamed of. Dogs are officially uninvited, but locals who have grown used to the crowds of tourists peering at their daily lives from this 1.4-mile observation deck might occasionally sneak their dogs up to enjoy the view.

"Where I was born, in the Soviet Union, people didn't really have too many pets," Dr. Alex Rubinov says. "My parents, when we emigrated to the US, didn't think to get one; they hadn't grown up around pets, either. But now I can't imagine my life without Sadie. She immediately became part of the family." Sadie is a compact little lady dog; some might even say she's petite. Her rescuers thought she was probably some kind of Labrador–Rottweiler–pit bull mix, but a genetic test showed her to be American Staffordshire, German short-hair pointer, boxer, and Chinese Shar-Pei. An international blend.

Alex adopted her at the tail end of his time at Columbia's dental school. "I was moving on to a new phase in my life: I was no longer a student and researcher but a professional living and working in Manhattan. Sadie helped ground me and helped me focus on the little joys as I worked hard to build up my practice and my career. She has sort of helped usher me into the next phase of my life and gives me undying support every day. It's a pretty magical feeling, and I love to spend as much time with her as possible." That means she sometimes gets to come to work with him to his father's practice in New Jersey, though she stays home when he's working at his office in Midtown.

That the High Line connects Chelsea to its neighbors is apt, since the neighborhood itself has such a diversity of architecture and culture, from 1800s town houses to twentieth-century public housing, old performance halls, and converted galleries. "One of the great benefits of having Sadie is getting to meet plenty of dog owners in the neighborhood," Alex says. "One of our favorite activities when the weather is nice is to run along the West Side Highway. There's a jogging/bike path along the water. You may recall that it was the site of a terrorist attack recently, and that has changed the identity of the place—there are concrete barricades up everywhere. But when I go out with Sadie, she's oblivious to that, she is just always positive. That has helped me love my neighborhood: seeing it through her eyes."

MAGGIE, JARI, AND SOFIA & MARINA

INWOOD, MANHATTAN

Marina and her dogs are fixtures in Inwood, even if people may not know their names. That's the thing about dog people. "Inwood is a huge dog community," actor Todd Cerveris says. "I've had wholly language-free interactions with complete strangers about my dog or theirs, what they're up to, how they're getting along, what they're getting into. I've made friends with whom I first bonded over our dogs but now celebrate New Year's Eve or the Super Bowl or a new baby. We're like a little village, in the middle of a monster-sized city. And in a very real way, dogs keep us connected across gaps of culture, demographics, or even language. They humanize us. They civilize us. There are people here whose last names I may not know but whose dogs I never fail to stop and scratch behind the ears."

Like many of the city's strongest dog neighborhoods, Inwood occupies a geographical dead end, which is one of the things that makes it so bonded. People don't pass through; they come with purpose and intention, and that brings an inherent sense of respect. It is dense with parks, including Fort Tryon Park, whose winding roads lead up to the top of the hill where the Cloisters, holding an enormous collection of medieval art, stands sentry. Among the treasures are dozens of tapestries with dogs sitting at the subject's feet.

Marina spends much of her time working and caring for her ailing mother. For most people, this would be enough, but Marina cares for dogs as well. Not just her own but the strays and neighborhood dogs that she encounters every day on her way to work and back to her mother.

Jennifer Bristol, another Inwood dog owner, knows Marina well. "She has been a fixture in our neighborhood for years. Her dogs were dogs that originally were abandoned or needed to be rehomed. Marina doesn't just help the lost or found dog, she helps people. She does lots of outreach and encourages people to get their pets spayed and neutered—and sends them to low-cost options."

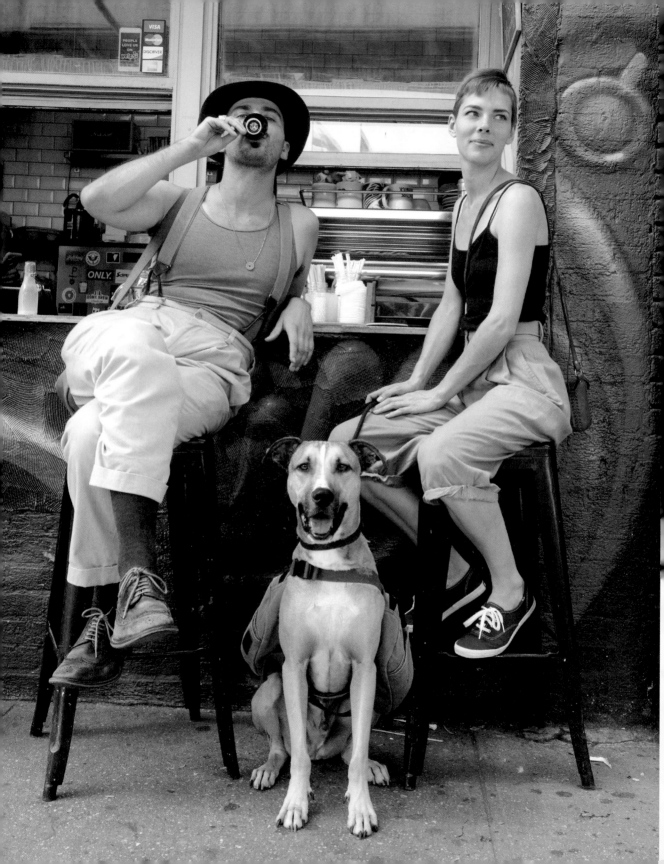

MARLOWE & LEAH AND JONATHAN

BUSHWICK, BROOKLYN

Marlowe started his life in the Bronx, where his first owner had to give him up to the city shelter. He cried so much when his owner left that one member of the staff worked the entire day with Marlowe in his lap. Marlowe went to live in the Hudson Valley until he found his forever home with artists Leah and Jonathan in the Bushwick neighborhood of Brooklyn. It's an old walk-up, and Leah and Jonathan are the only people in the building who aren't related to everyone else. "We're so lucky," they say. Every couple of years an investor will buy the property, thinking that they might be able to get everyone to move out, do a quick renovation, and raise all the rents, but no one is budging.

Marlowe isn't going anywhere, either. "I don't know what we did before he got here," Leah says. "Everyone in our building loves him. Even one girl who is terrified of dogs fell in love with him. Now whenever she sees him they high-five. It's Marlowe's favorite trick." In a room converted to a studio in the front of the apartment, Leah creates enormous, finely detailed charcoal drawings, some of which have been featured on the cover of *New York* magazine. She considers Marlowe her studio manager. Under the drafting table is an elevated dog bed, so when she is working on difficult master sketches, Marlowe remains perched just inches from her lap. The only thing he takes more seriously is accompanying emergency vehicle sirens with his own trilling howl.

When it's time for a break, everyone takes a walk down the street to Mixtape, a tiny espresso bar beneath the elevated subway line. "The biggest problem with Bushwick is all the trash on the street," Leah says. "Marlowe sees it as a never-ending buffet. So many chicken and pork bones."

Marlowe misses his best dog friend, who recently moved away, but he's always welcoming of new dogs and new people, which is a treat in a dog if you are an artist who spends so much time in your own head. "He's the only dog I've ever had that loves going to the vet."

CRICKET & SAMUEL, SARAH, AND TIM

CROWN HEIGHTS, BROOKLYN

When Sarah and Tim brought Samuel home from the orphanage in the Democratic Republic of the Congo, they couldn't believe what a confident toddler they had. He cheerfully greeted everyone they encountered, even when they boarded the enormous plane back to the States. His reaction to their beloved dog, Tuki, was another story. Tuki was a brindle-striped mix from the streets, and when Samuel spotted her in their apartment he began screaming and frantically climbed into the safety of their arms. They were devastated; they loved Tuki but realized that they might have to get rid of her. Thankfully, a common interest finally bonded the two: food. At the local deli, they bought crackers for both their child and their dog; soon Samuel was laughing and dropping his crackers into Tuki's mouth. They were friends and never looked back.

Crown Heights is in the center of Brooklyn, and the center of Crown Heights is the tree-lined boulevard, designed by Frederick Olmstead, called Eastern Parkway. Tim and Sarah moved there from Manhattan in 2007 because it gave them the space to live affordably in a small apartment while Tim grew his design business and Sarah continued her dual career as a schoolteacher and a yoga

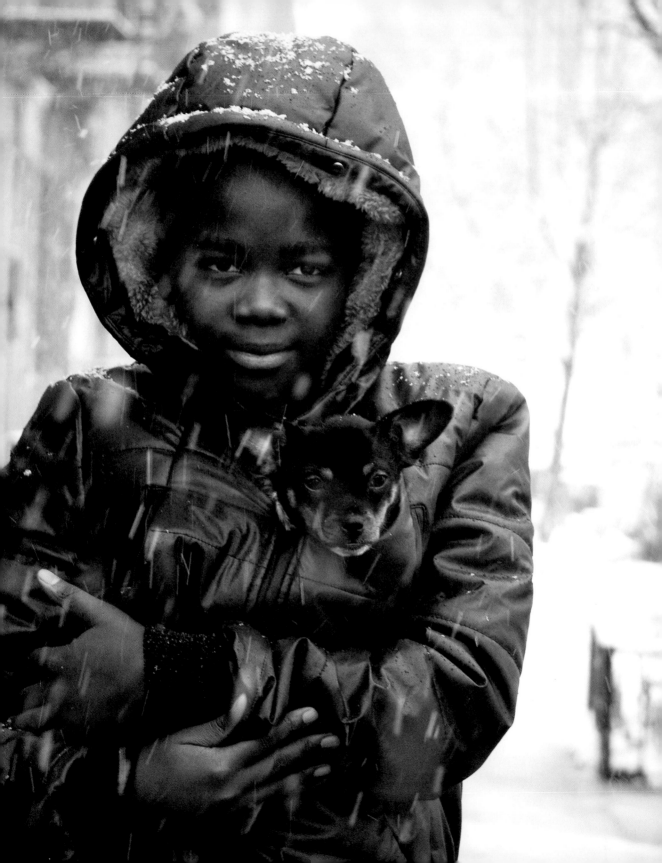

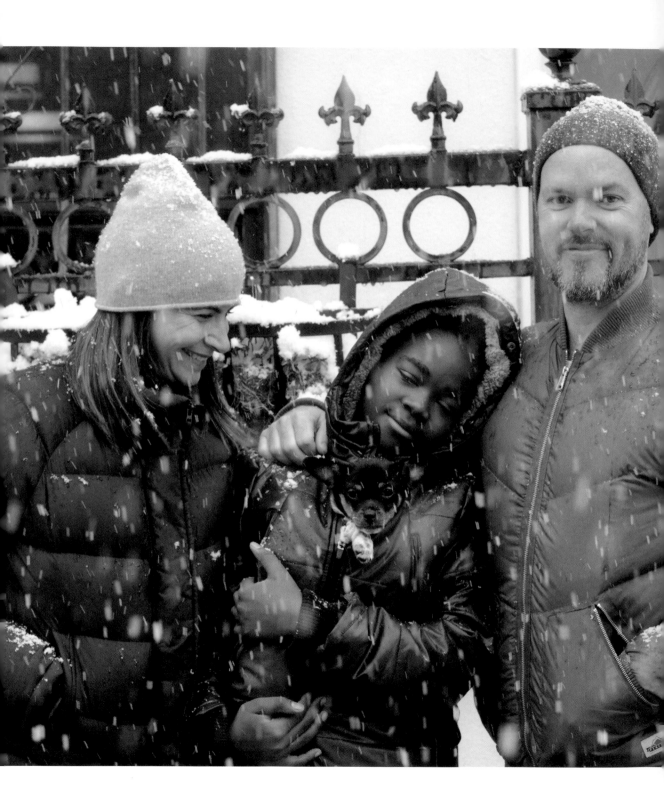

studio owner, which was more of a community endeavor than a job. Ten years later, the rents have caught up, so the yoga studio will be closing. Sarah has accepted that change is inevitable but worries about losing the community that developed behind those doors.

"Having a dog in this neighborhood is such a connector," she says. "Tuki loved to exercise, and we often spent hours exploring our neighborhood and adjoining ones, going to the park for off-leash hours, or jogging laps around the park. Along the way we met so many people. I have really fond memories of taking Tuki to off-leash hours during the winter when she was little, meeting up with fellow dog owners, and walking the length of a snow-covered Long Meadow, lit bright by the moonlight."

When Tuki passed away they mourned as a family and didn't even talk about getting another dog—who could replace her? Then one day, Sarah decided to stop by an animal adoption event, "just to look." "Cricket is proving to be equally magnetic—she's pretty cute and her high-stepping prance brings such a smile to passersby," she says. "In the first days of having Cricket, Samuel often mentioned that he didn't feel that connected to her. And we let him know that that makes sense because he knew Tuki longer. Over the past few months he's made comments that he's feeling more connected to Cricket and mentions her features (she's a fetch dog, for example) that he appreciates. Again, what a gift—to learn what it means to love, lose, grieve, and go on, without entirely letting go."

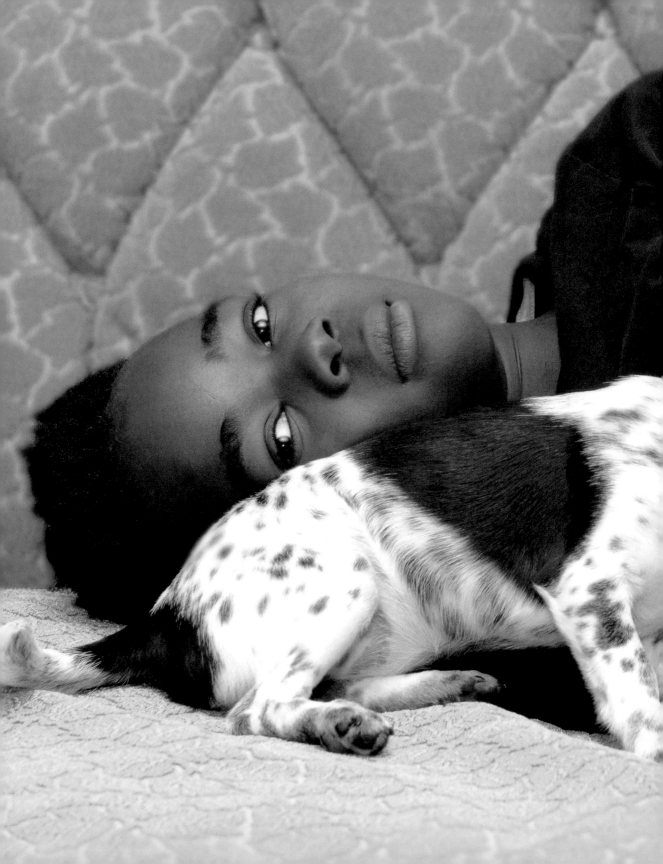

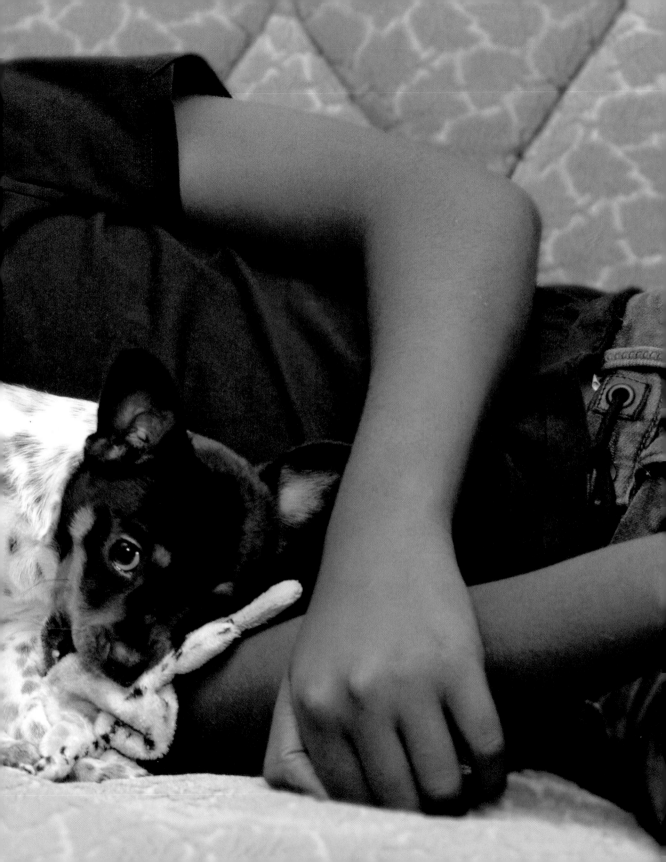

SHADOW & SHAUN AND NORA

NEW BRIGHTON, STATEN ISLAND

Shaun knew he was going to marry Nora as soon as he met her. He was in seventh grade and she was in sixth. "I was in the hallway and she stormed out of the classroom; some students were bullying her because of her heritage. She walked past me crying, and I asked if she was okay, and she just looked at me and walked away. I didn't really see her after that until around a month later, when I moved to a new building complex. While I was waiting for the school bus I saw her walk out of the other building with friends. That's when I knew."

Shaun works nights doing construction while Nora works days as a substitute teacher. Their schedules are what initially inspired them to get a dog; he didn't want her to be alone at night while he was gone. But they disagreed on what kind to get. Nora wanted something small and manageable. Shaun wanted a big dog. He had grown up with a German shepherd/border collie mix named Xena. "She was very gentle," he remembers. "She loved to play outside, but when she heard thunder she would squeeze beneath the kitchen sink." She lived to be sixteen.

Shadow, being a large, exuberant puppy, is a bit of a challenge for Nora. He pulls hard when she walks him. He steals kisses and catches her off guard. "He loves the outdoors," Shaun says. "He loves the nature walks on the beach and in the Greenbelt nature park here on Staten Island, where we walk and explore for hours. He loves car rides around the city as well. I've always loved animals and nature, but the walks with Shadow bring me to places where I really get to see the in-depth beauty of the simplest things. Shadow has made me a better person."

As Shadow matures, he also has begun to find some interest in more urbane activities. He loves to walk around the corner to visit the owner of the Mediterranean restaurant. Even Nora is coming around. "Nora has definitely gotten used to Shadow and now even allows him to lie with us on the couch," Shaun says with a laugh. Shadow clearly has these people well trained.

STELLA & JORDAN AND LARON

WEST HARLEM, MANHATTAN

Jordan and Laron met as students at Howard University, but they didn't become a couple until they both ended up in New York, and didn't become a family until they met Stella. It was Laron's idea to get a dog, and he'd fallen in love with French bulldogs and their ridiculous expressions. Jordan was skeptical. They had both grown up with dogs, but Jordan didn't think he was ready to add another responsibility on top of work. And Laron's job was moving to Boston, which meant splitting time between two cities.

But then they met Stella. She is as socially confident as she is physically compact. When she meets someone, you get the sense that her tiny brain is wondering why she hasn't met them sooner. She maintains eye contact like a sales pro while extending a paw. She makes life in Harlem even better than Jordan and Laron could have imagined. She's also easy to travel with, so she gets to spend time in Boston, but Harlem is home.

"In Manhattan, there's so many tourist attractions, hotels, colleges, and businesses that it can be a challenge to find some peace of mind," Jordan says. "In Harlem, we have access to some of the best soul food restau-

rants, live music, cultural events like the African American Day Parade, and sneaker shops. It provides the access of living in Manhattan with a bit more opportunity to disconnect and enjoy the people. Having Stella keeps us in Harlem more often, which isn't a bad thing. We are more likely to recommend dinner in Harlem at places like BLVD and Fumo during the week so that we can get back home to her."

Harlem was founded by the Dutch in the 1600s and named for the city of Haarlem; the local architecture is still dominated by distinctively tall town houses with high stoops. Over the years, Harlem saw its popularity ebb and flow until the jazz era, the Harlem Renaissance, and the Black Arts movement brought it back into cultural prominence. Today one can find the big national chains on 125th Street, but the heart of the community is found on side streets and the avenues named after Malcolm X, Adam Clayton Powell Jr., and Martin Luther King Jr.

Stella, like most dogs, doesn't concern herself with history. She's only concerned with the here and now, Jordan and Loran, and the memories that they'll make together.

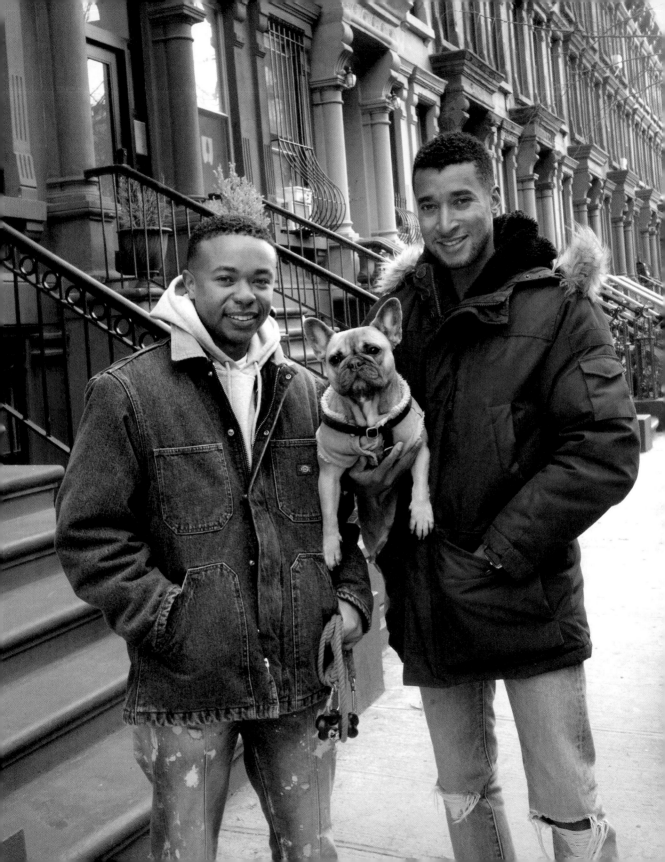

MATILDA & RICK
SUNNYSIDE, QUEENS

Matilda is the OG of Sunnyside's dog park, and at fifteen years old, she has a quiet sense of authority about her. Rick had never had a dog, but after a marriage gone bad and a move to Queens, he noticed a group of people who hung out every day in a corner of Lou Lodati Park. They were there with their dogs. They seemed happy, their differences seemed to be immaterial, and they convinced Rick that he should consider getting a dog so that he had a reason to hang out, too.

Here's the secret: none of them was really supposed to be there. There was no off-leash area at the time, but there wasn't much happening at the park with or without dogs, so the dog owners decided to take the lead (so to speak). They formed Sunnyside United Dog Society and began advocating. It wasn't easy. They didn't know what they were doing. But they didn't let it go, either. They raised funds through creative endeavors like a Sunnyside dogs calendar, and they raised awareness by demonstrating responsible dog ownership and actively engaging with neighborhood representatives.

It took more than ten years, but their persistence paid off, not just with funding for a dog park but renovations for the entire park, including new fields for humans, too. The dog section is uniquely decorated with holiday ornaments in the trees and bushes all year round.

It took Matilda and her friends twelve years to bring change. Some of her dog friends didn't live long enough to see it. But that's how community works: you may be inspired by your own needs and desires, but your actions, ultimately, are about making things better for those who will come after. With that in mind, there's a section of the fence at the park dedicated to those dogs who came and left; their tags hang side by side from the chain link, and they will always be there.

"Before Matilda, I knew maybe one person in Sunnyside," Rick says. "Now I seem to know everyone. She taught me what community is all about."

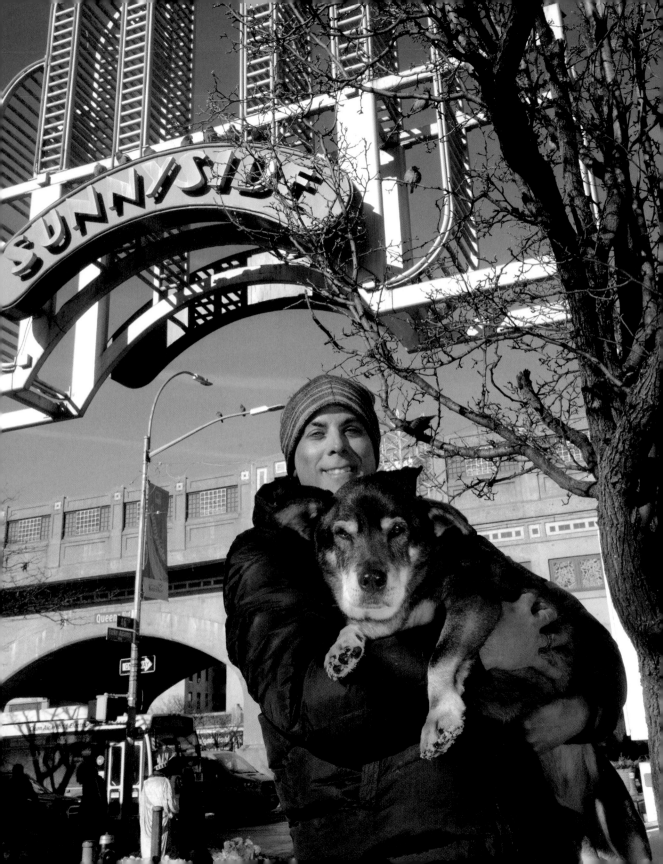

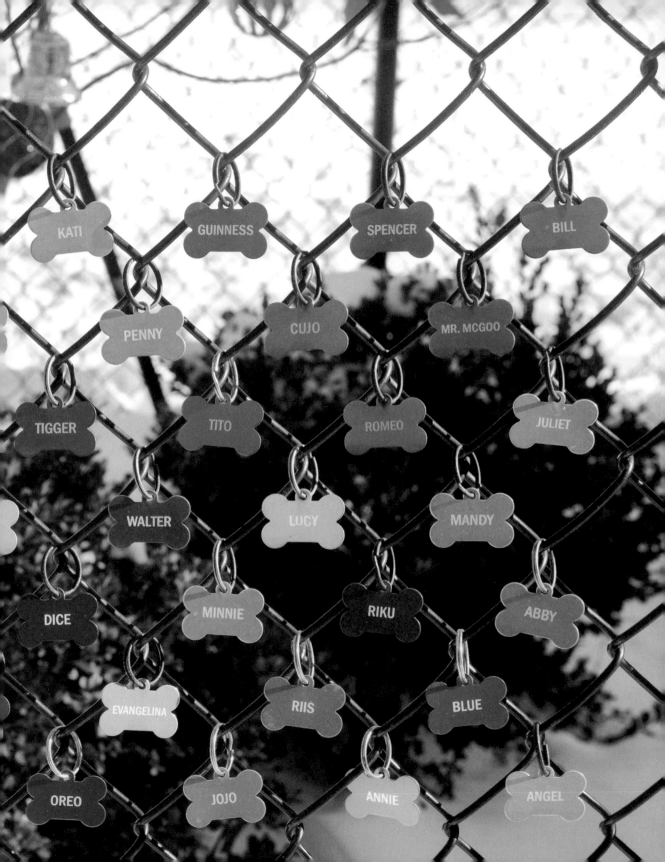

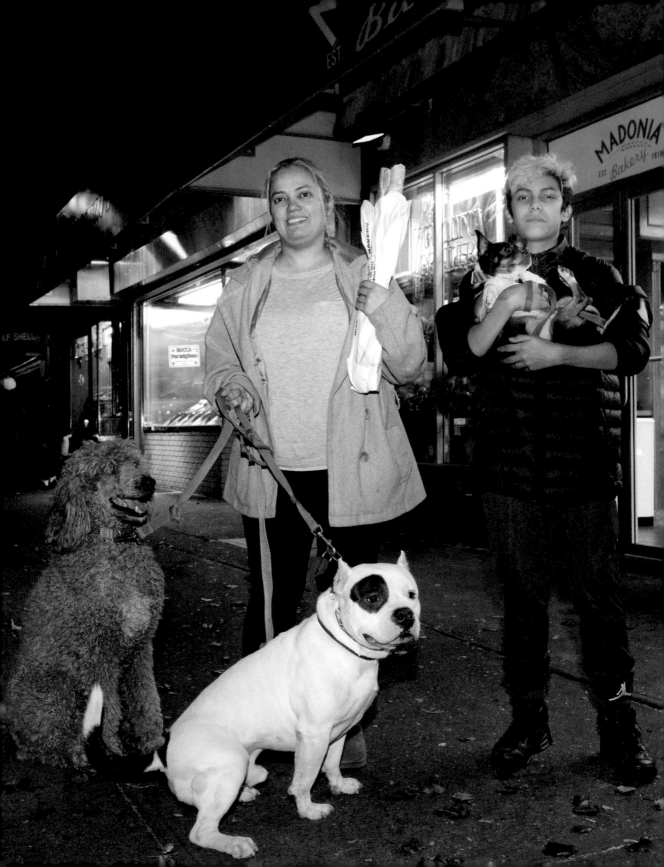

ROCKY, SANDIE, AND BULLIE & HILDA AND ISAIAH

LITTLE ITALY, THE BRONX

Growing up in Washington Heights, Hilda was always bringing animals home: dogs, cats, turtles, guinea pigs. "My mom was probably tired of it," Hilda says. "But she never said no." Even injured pigeons found refuge in their apartment. "We would heal them, with injured wings, and then let them go." Things haven't changed much now that Hilda is a mom herself. The neighborhood has gone through ups and downs, but Hilda and her son, Isiah, are still opening their doors to animals. Rocky, a Chihuahua mix, came from a family that could no longer keep him. "He was so nervous when he arrived," Hilda says. Sandie, the poodle, came from an uncle who passed away. She's been with Hilda and Isiah since she was about two years old; now ten, she's still rambunctious enough to literally jump at the chance to steal a baguette on Arthur Avenue. And the newest addition is Bullie, who arrived covered in cigarette burns. "It took a long time to train him," she says. "We're still working on it. But I would never give them away." They also have two cats.

Hilda and her gang live near the Bronx's Little Italy, where each store specializes in a specific ingredient (ravioli, mozzarella) and families stop in for that one thing, like in the old days. During the holidays, bright, welcoming holiday lights stretch over the streets. There's a lot of pride in everything that takes place here, even if you really have to be from the neighborhood to know that it even exists. Hilda works at a school during the week and helps out in a relative's business on weekends.

"These dogs are our happiness," Hilda says. She and her son both have post-traumatic stress disorder, and their three furry family members offer a buffer to their anxiety. "Both my son and I can sleep better; without them our home wouldn't feel like a home. My son says they are his brothers and sisters. It is a big difference growing up with animals in the city. You learn compassion, selflessness, patience, and unconditional love. More kids who don't have pets should, especially children that have emotional or mental disabilities; it helps so much." Rocky has anxiety too but calms down when Isiah handles him.

"Being patient, thinking about other living things before just thinking that they don't understand, I realized how much animals comprehend everything. Whether you're skinny, fat, black, brown, or white, they don't care; they will love you no matter what. This is what we have learned from them."

RED AND GRACE & LYDIA

UPPER WEST SIDE, MANHATTAN

It's not unusual to see Lydia's dog Red performing tricks on the Upper West Side, if you are the kind of person who might notice such things. There he is running parkour along the stone walls that mark the boundaries of Central Park, or walking down Columbus Avenue with a basket of wine. Lydia is a dog trainer, although that title ignores the work she's done with goats, rats, and chickens that have been cast in Broadway shows after their time together, sharing the stage with everyone from James Franco to Lea Salonga. Her own dogs have to have a few tricks up their sleeves as well. Coming up with new challenges is a way to keep herself sharp—as well as the dogs.

At night, they go into Central Park and explore. Dogs are allowed to roam off-leash and the park becomes an otherworldly place, lit by scattered lamps and the moon reflecting off the water. It gets busy at night, with groups of dogs and their people passing every which way. "Don't go in that direction," Lydia warns a group as they head down one path. "Raccoons."

Red also gets to spend time upstate in the country with Lydia's ex. "Red gets to run off-leash in Central Park on a regular basis, so the country, although interesting to him, is not

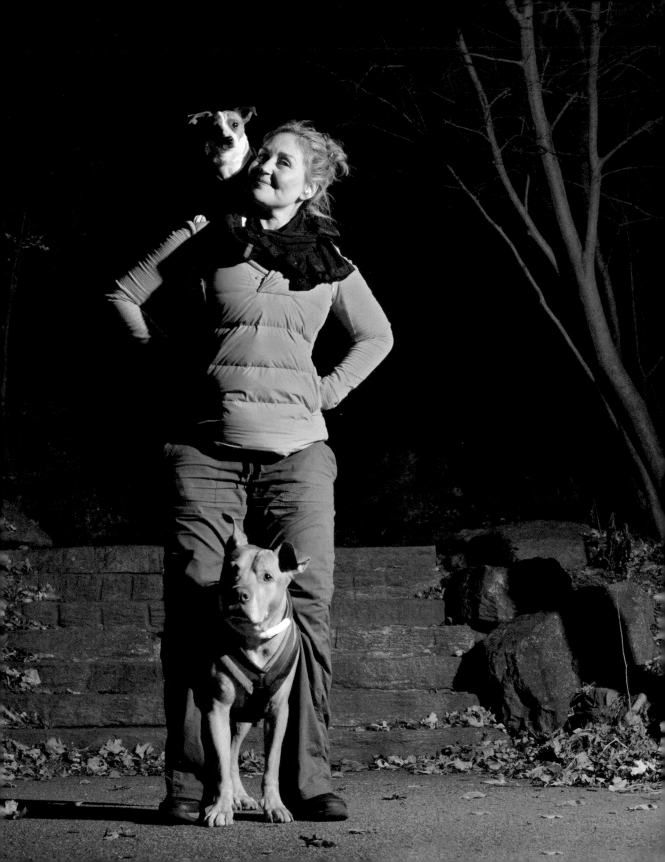

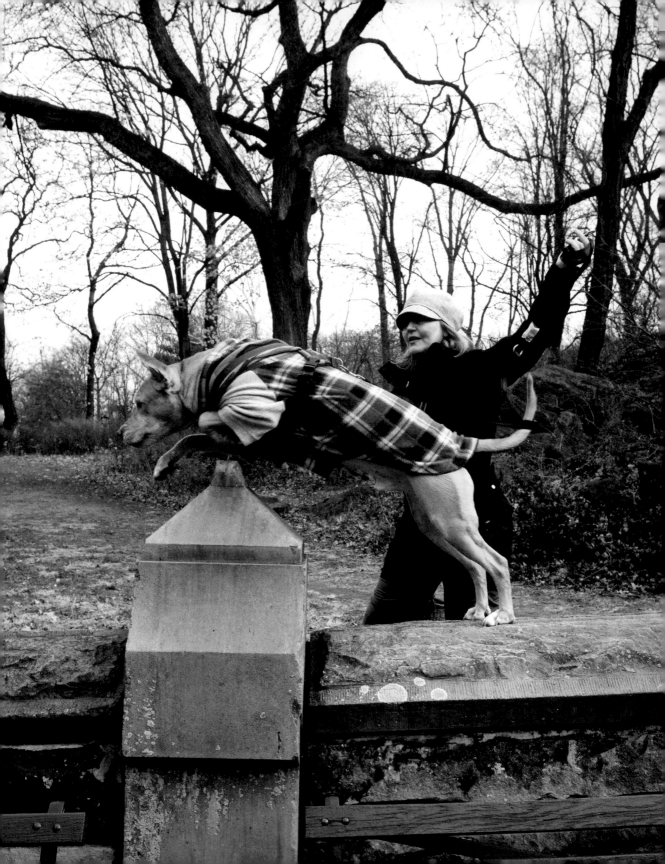

the biggest thing in the world," she says. "He and Grace get so much Central Park time that they would both rather go to the pet store. Red also loves to carry his basket around Manhattan and be admired by humans. He also enjoys a good party and can be found either by the food or passing out drinks. Ask anyone who has been to a party with Mr. Red. He is the life of a party. I've considered renting him out."

This isn't the direction Lydia expected to go in when she moved to New York in the 1980s to pursue a career in the fitness industry. When she committed herself to a dog with behavior issues, the first trainer she consulted abandoned the case after the pup bit her; the second recommended euthanasia. "The dog had never bitten before," she says. "And he never bit again." Determined to find a solution, Lydia dove headfirst into the field of animal training and kept pushing herself further in her study. No doubt the discipline she learned in the fitness industry helped push her along, but the dogs guided her.

THE MENAGERIE & MONET, JAMILLA, AND ALFREDA

FORT GREENE, BROOKLYN

Life in the city can be chaotic, and the life of a musician even more so. Between auditions, gigging, teaching, and helping out on a friend's film, it's a comfort to come home to a pet, or even a few pets, or perhaps more than just a few. Monet's house sits on a quiet corner of Fort Greene, in the shadow of the Brooklyn-Queens Expressway, also known as the BQE. Her home is so efficiently managed that you might easily miss how many pets there are on any given day. They tuck themselves away into the back rooms and between furniture, outside in the yard, under the covered patio, or in the back building.

A decade ago, the house burned down. Monet ran into the fire to try to save her Rottweiler, Yogi, but it was too late. She's been rebuilding since then, both the house and her life, because when you lose something that important, it takes more than material objects to recover. "Contractors made my life living hell," she says. "I am still looking for one who took all of my money and left me to build what I could on my own . . . the builder made a mess of my house."

Her daughter, Jamilla, adds, "It took us a long time. Dogs are great because they help you heal. When it feels like your world is falling apart, it's great to have some kind of sup-

port system, and your dogs are always there for you."

"Animals have always been a part of my life," Monet says. "My first dog was a boxer named Lani. The next was Princess and her daughter Cindy. I also had Kenya, who went with me to college. Kenya lived with me until she died peacefully of old age in the kitchen in Brooklyn. Carl was born on Carlton Avenue and stayed here until he also died of old age. Mom always allowed me to have a dog or two."

Her mother, Alfreda, is visiting with her own pups, RaeRae and Mr. Ed. Her first dog came to her in 1955—a black Lab named Teddy. When her husband was assigned to the 25th Infantry in Hawaii, they had to leave Teddy because of quarantine requirements. But in Hawaii they took in Lani, who became Monet's first childhood dog. Listening to the three generations of women speak, it's clear that there's an underlying order to their overlapping dog family tree.

"My daughter had Carl, who loved her to pieces," Monet says. "There are photos of her on his back, and his big black snout in her little face giving her kisses. Now she has Bella and McCoy, who are always with her. Mom has just enough hands for her two fur sons, Ed and MaeMae."

Jamilla says, "I have never lived without having a dog. Having a dog is like having a sibling, someone who is always there for you."

"First Jessie, then Jay," Monet says, listing the dogs who moved in, even temporarily, after they returned. "Then Jack, Joss, Joey. McCoy, Popcorn, then Max and PorkaTone. Saving these sweet babies, providing them with love, shelter, medical care, and attention was healing all the way around for all of us."

Life is a roller coaster, whether you have a houseful of pets or not. Alfreda, more than anyone, knows how much pets can be a stabilizing influence. "Life for me was never lonely," she says. "There is joy and unconditional love. Whatever personal challenges I experienced, I could always count on my pets, who seem to know exactly what I need, and I don't have to ask."

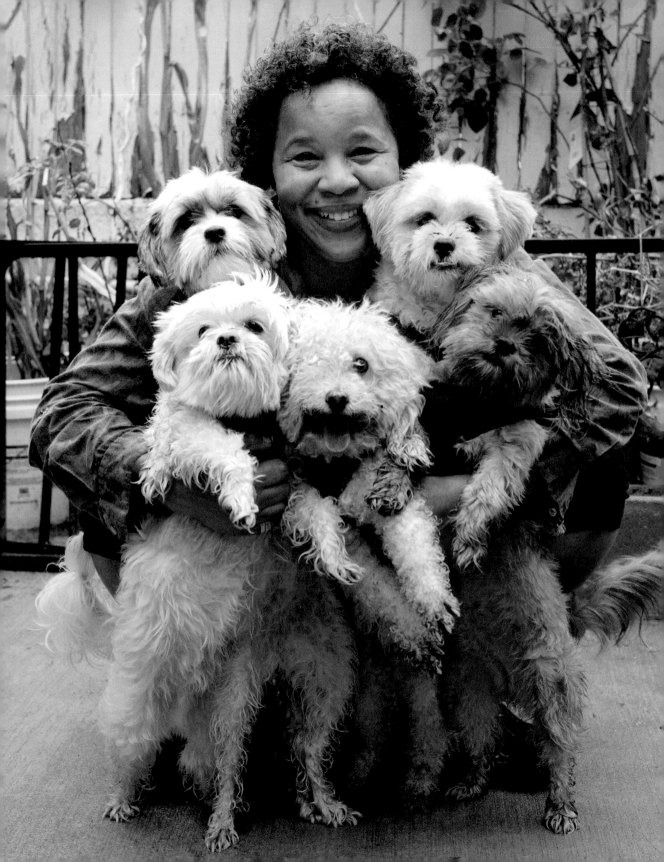

The naming was the hardest part. They waited a long time to get a dog, so long that friends assumed it would never happen. Like many things in life, it happened slowly and then all at once. From the moment Asenath saw the stray, she couldn't stop thinking about him. But once they brought him home, there was a stalemate when it came to his name. Her son, Aydain, suggested every *Star Wars* character, in succession. Asenath and Luis each made their own lists, and then the family narrowed down the possibilities to something they could each live with. Sitting in a circle, they took turns calling out the names that remained in contention. It was "Rudy" that he barked back at. His name was Rudy.

Flushing is a mostly residential neighborhood, but with Rudy in the house, they have an excuse to explore a little farther from home. Flushing Meadows–Corona Park is the 897-acre public park that hosts the US Open. It is also famously the site of the 1964 World's Fair, and the twelve-story stainless-steel unisphere remains a central landmark. In winter, with the fountain emptied at its base, it's not unusual to see dogs trying their best to run under the globe.

Closer to home, Aydain finds an empty lot where he and Rudy can practice fetch while his parents watch, and it's hard to imagine that the dog has been with him only a few weeks. Asenath says that having a dog in the house has made them all more active—and she finds herself talking to more of her neighbors as they pass on their walks.

Books will tell you that having a pet teaches responsibility. This dog does something else, too: With his people holding him in their arms, he completes a family picture.

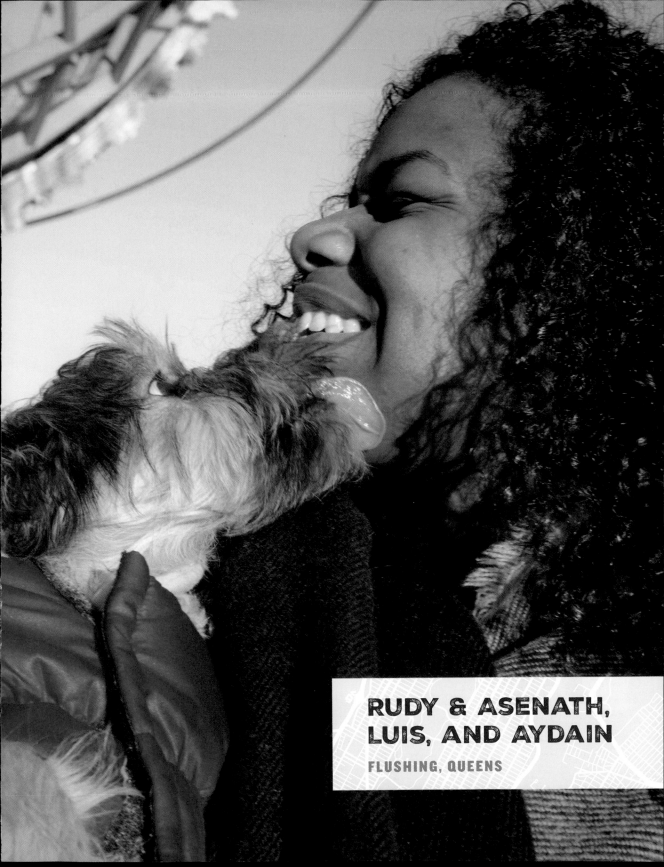

RUDY & ASENATH,
LUIS, AND AYDAIN

FLUSHING, QUEENS

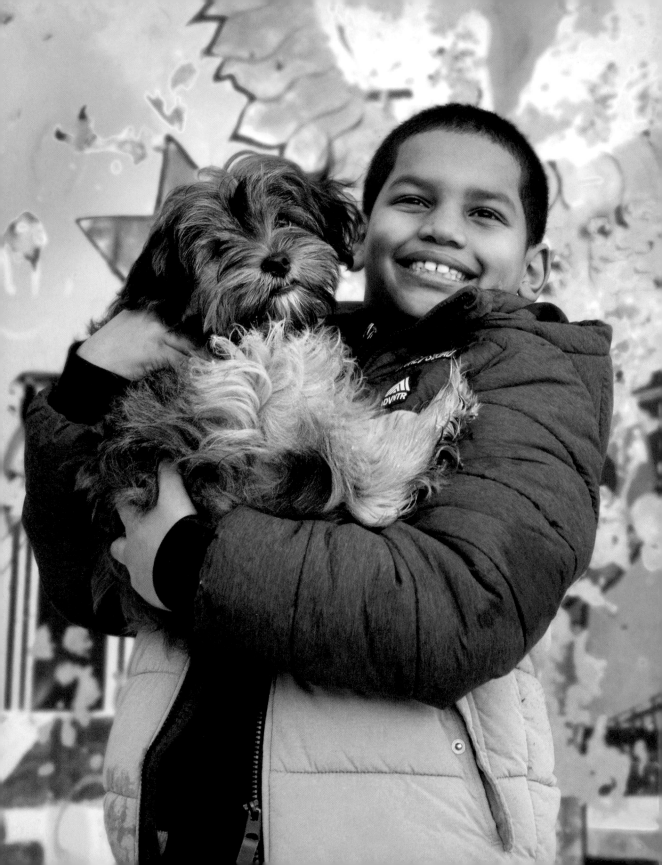

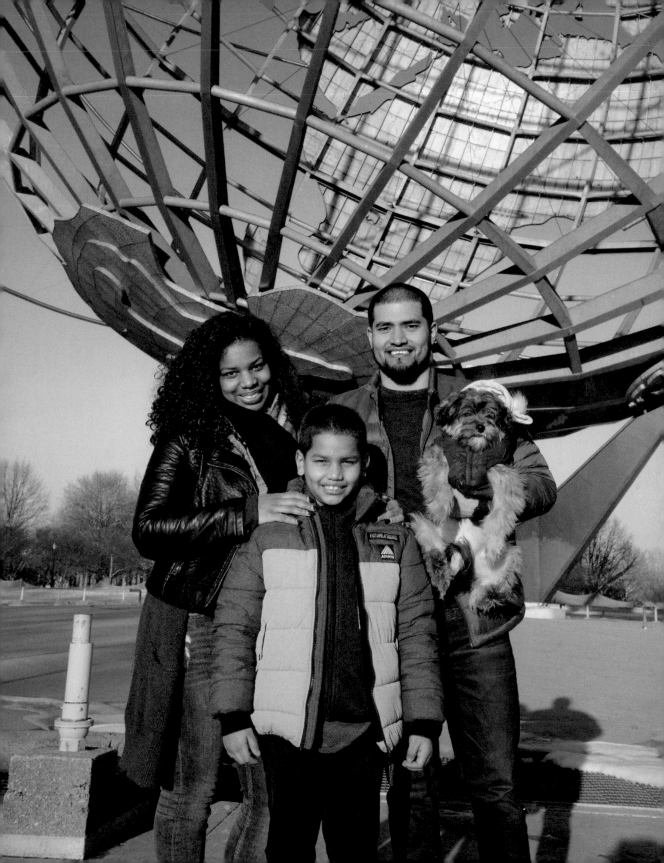

JULIE & KAROLEE AND JOE

CITY ISLAND, THE BRONX

In the summertime, City Island is packed with weekenders and city tourists, crowding the beach and filling the many seafood restaurants on this tiny isle just off the coast of the Bronx. It feels like a small New England town, despite being spitting distance from Manhattan. Zoning restrictions have kept tall, high-density buildings out, which is exactly how the residents want it. This is a rarity in the city: waterfront property, not far from the highway, without any high-rises stealing the view. The locals wonder how much longer that will last.

On Orchard Beach, on a chilly autumn morning, Julie is in her element. The park employees know her name. She moves slower now than she did when Karolee and Joe first brought Julie from the shelter in Harlem. "I spent twenty-five years without a dog," Joe says, "because my other . . ." He hesitates. "Wife," Karolee says. They laugh. "My other wife didn't like dogs. I put up with that for twenty-five years."

Joe grew up loving dogs and coming to Orchard Beach, though things were different then. Looking out at the numbered markers across the sand, he says, "Section two was only for the Puerto Ricans and the blacks. That was the only place we could go. The police would beat you up if you weren't in the right section." Nevertheless, it was a refuge on hot summer days for people who couldn't get farther away than the Bronx.

Karolee says, "I came up on a date—different man—and fell in love with the place." After she and Joe got together, Karolee called him to work one day. A dog had followed her into her office and curled up beneath the desk. It was so small and scrawny that her coworkers thought it was a squirrel. That was their first dog together. They named her Jessie, and once she was healthy, she turned out to be a Cairn terrier. She lived a long life and died one Christmas night. They made no immediate plans to replace her, but one Sunday on the ride home from their favorite diner, Karolee told Joe that she'd dreamed they had a new dog. Without a word, he turned and drove straight to the shelter on 110th Street. "Julie was coming in off the truck when she arrived," Karolee remembers. "She came right up to me."

"It was April fifteenth," Karolee remembers. "Tax day."

Joe says, "People always ask how much we paid for her."

These days Joe stays home with Julie while Karolee works her final years before joining them in retirement. Each morning they drive her to the ferry and say good-bye, and they are there waiting for her every afternoon when she comes home.

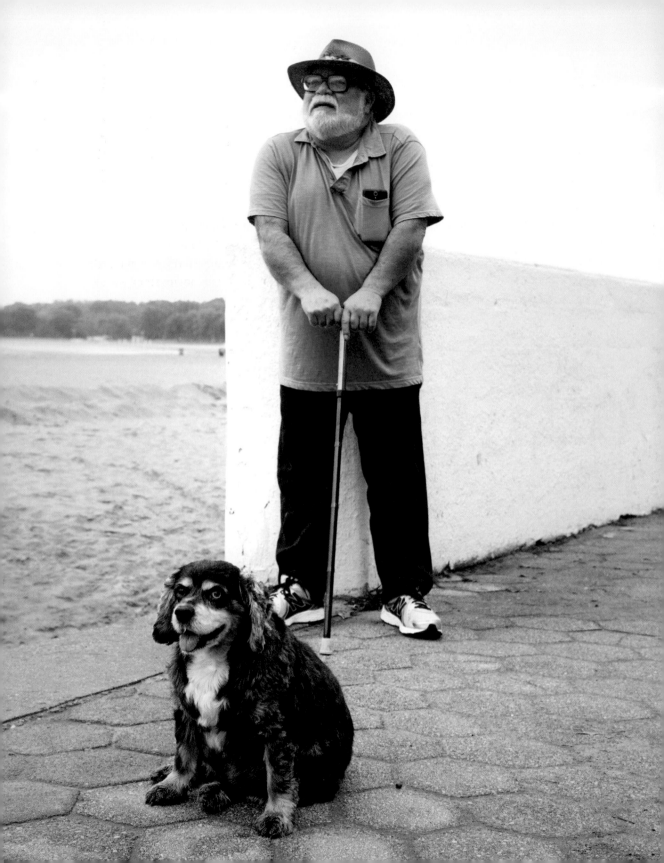

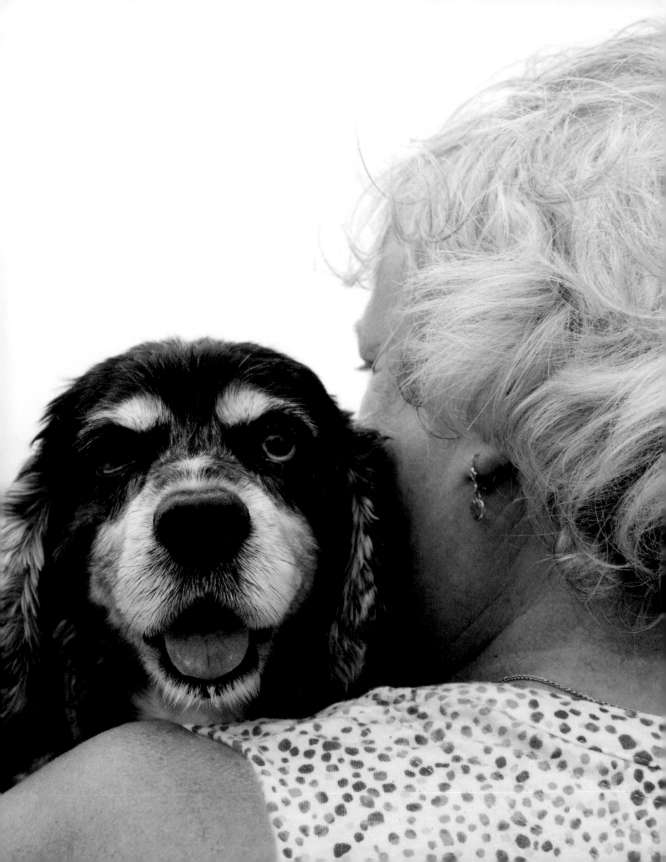

KAHUNA, REMY, AND PIGGY SMALLS & RACHAEL

Rachael grew up in a kennel. Her father's business, Whitestone Pets, was her afterschool playground. She would climb into a kennel with her homework and once she was done, she would spend the rest of the afternoon playing with the dogs that were boarding there. When she was older, she started working there, though she realizes now that it was her father's way of keeping her too busy to spend time with a boyfriend he disapproved of. "He was very smart," she says. "Because he knew that if he were to tell me no, I can't see him, I'd have just gone behind his back. Instead, I was just too busy working with my dogs." Now Rachael keeps the place running. "It completely shaped who I am."

If you aren't from Whitestone, your only association may be the Whitestone Bridge, or more specifically, a desire to avoid the Whitestone Bridge on your way to the highways north of the city. Passing over the neighborhood, you'd never picture the community that you are bypassing. You would never guess that beneath the bridge, Rachael is playing fetch on the beach of Francis Lewis

Park. Kahuna is the oldest, a Rottweiler Rachael left with her father when she moved in with her fiancé. She didn't want to leave him completely alone. Remy is the younger Rottweiler, and Piggy Smalls is the French bulldog, who causes the most trouble.

"She'll self-mutilate if me or my fiancé aren't with her," she says. "We tried so many things to help her with that. But what works is just taking her everywhere. We're always on the lookout for pet-friendly options, and, of course, I can always bring her to work."

She was a little embarrassed by her family business when she was younger. Once they even used a photo of Rachael in one of the kennels as part of an ad campaign; it ended up on Jay Leno's show. "People look down on those of us in the pet industry; they say it's not a 'real job,' but trust me, it is," she says. And she's learned a lot from being at the center of so many lives. Dogs set a great example for how we can all learn to relate to one another. "They'll tell you when they like something or don't; you just have to pay attention."

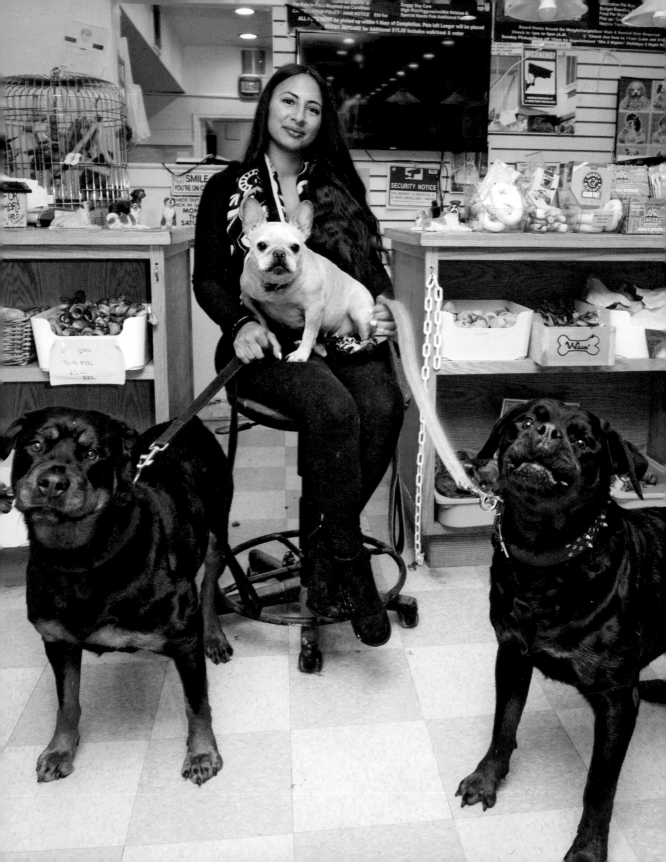

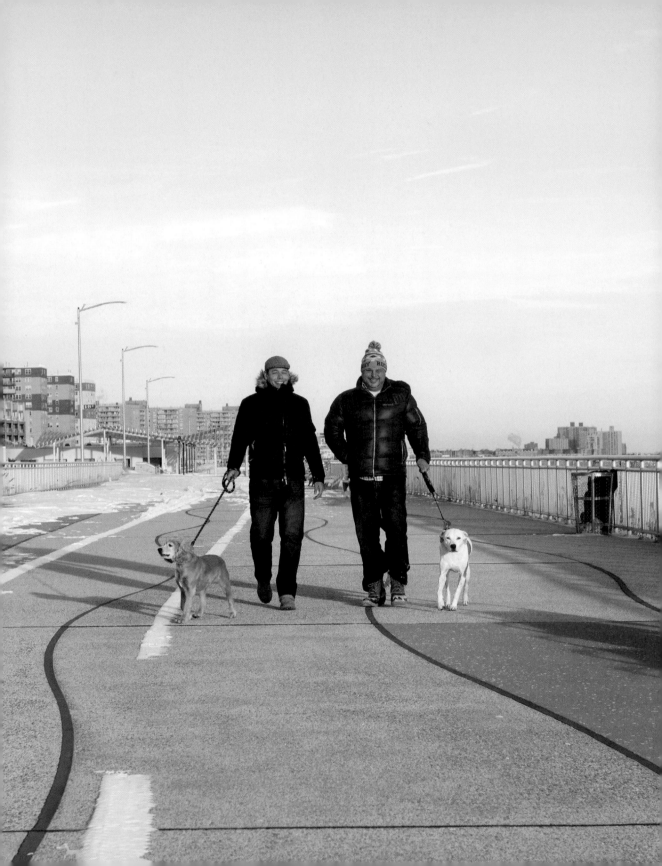

MILLIE AND MANCHA & ROB AND ALEX

ROCKAWAY BEACH, QUEENS

Rob says the dogs listen better to Alex than to him. Alex says he is wrong, that the dogs in fact prefer Rob. Rob says he pursued Alex; Alex insists that it was the other way around. Perhaps, they agree, it was mutual. So it goes with these two, or four really, since you can't talk about them without including their dogs.

Mancha means "spot" or "stain" in Spanish; Millie is the name Alex chose simply because it went well with Mancha. Mancha found Millie on the beach one day, running on her own. They tried to locate her owners and then tried to find another home, but it wasn't long before Mancha and Millie had settled into a routine together, and so she stayed. The family lives in an upper-level condo directly across from the beach and the boardwalk, which was recently rebuilt after being washed away by Hurricane Sandy.

Rob commutes an hour to his high school in the Bronx; it is a challenge, but the reward is coming back home to Alex and the dogs, and a view of the ocean that is clear enough to let you see the curve of the horizon. Rockaway Beach is the largest urban beach in the

United States, but the community has just over ten thousand residents. Rob and Alex used to spend a lot of time visiting during the summers, when Rob was off from his job as a high school dean. "We would talk about how great it would be if we could live here," Rob says. At the time they were living in Astoria, on the other side of Queens. "And then we realized that if we really wanted to, we could." They moved in just before the hurricane. Because they were on an upper floor, they could return sooner than most. Some of their neighbors on the first floor found parts of the boardwalk in their homes. "We really got to know everyone after that," he says. "Everyone was so dedicated to coming back."

Alex watches as Rob lets the dogs loose on the beach. Millie and Mancha run together across the layer of snow that covers the sand, and then Millie gets distracted by the dunes, and Mancha follows after her, careful to not let her go too far on her own. In the distance, there are surfers braving the freezing water. "In the winter," Rob says, "there are no rules here."

ZAK & KEREN

HELL'S KITCHEN, MANHATTAN

Midtown is base camp for actors in New York—it's where the theaters are, it's where the auditions are, and, if you are between gigs, it's where you might find work waiting tables so you can quickly dash out when you get that long-awaited callback. Keren grew up in Baltimore, with an iguana, a hamster, a cat, a cockatiel, and three dogs. As an adult, she didn't feel she had time, or a place, for a dog until she was cast in her first Broadway play, *The Curious Incident of the Dog in the Night-Time*. Each night, at the end of the second act, a puppy would run onstage and steal the show. "Once they got too big to pull off being a puppy, they would be adopted, and a new puppy would soon arrive," Keren says. "Every chance I got, I'd be in the trainer's room with Toby, our pet rat, and the puppy du jour. After falling in love with each puppy, and having to part with each soon after, I couldn't take any more. I had to get a buddy of my own!"

Keren is such a burst of energy that her young dog seems calm by comparison. It's a joyful, contagious energy, and as they walk around Hell's Kitchen, their human and dog neighbors all stop to say hello. "Having a dog in a metropolitan area can feel abnormal at times," Keren says. "Not enough space, no backyard or the rest of my family to play and socialize with. But you make do. We also go home to Maryland every now and again, where he runs through the yard until he's tired! He's a friendly little fella, so even a quick walk down our block is a socializing event." Even the most constricting spaces get a lift from having Zak along: "I used to hate navigating Port Authority and Grand Central because of the congestion and stress. Oddly enough, Zak loves both! He's so happy and enthusiastic in the wide-open spaces, and it lifts the spirits of me and every commuter walking toward us. He pretty much keeps up the morale during rush hour."

Zak is such an essential support system, he even sometimes goes along on Keren's auditions. But he doesn't help run lines as she prepares script; "I send him out to walk with friends," she admits. "Momma has to get in the zone."

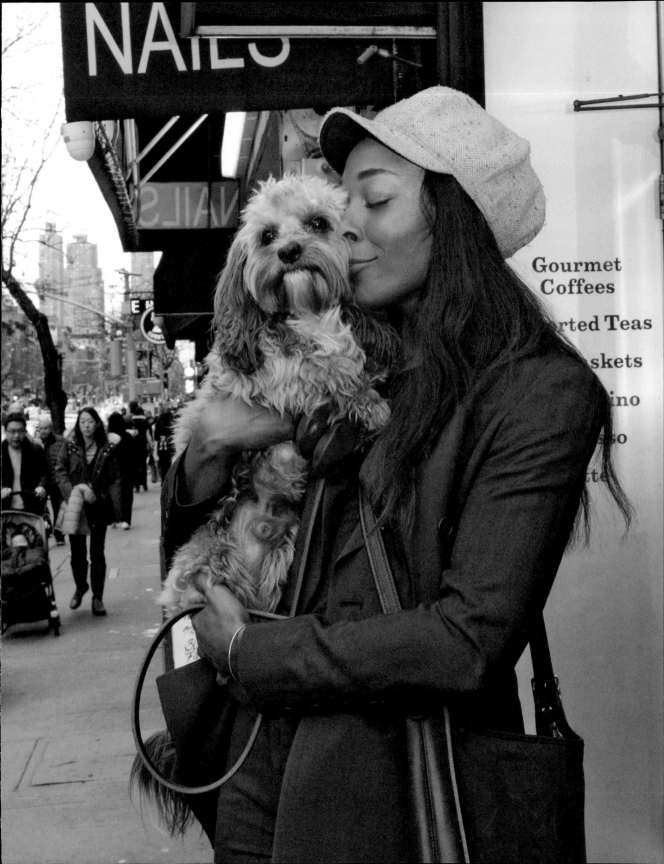

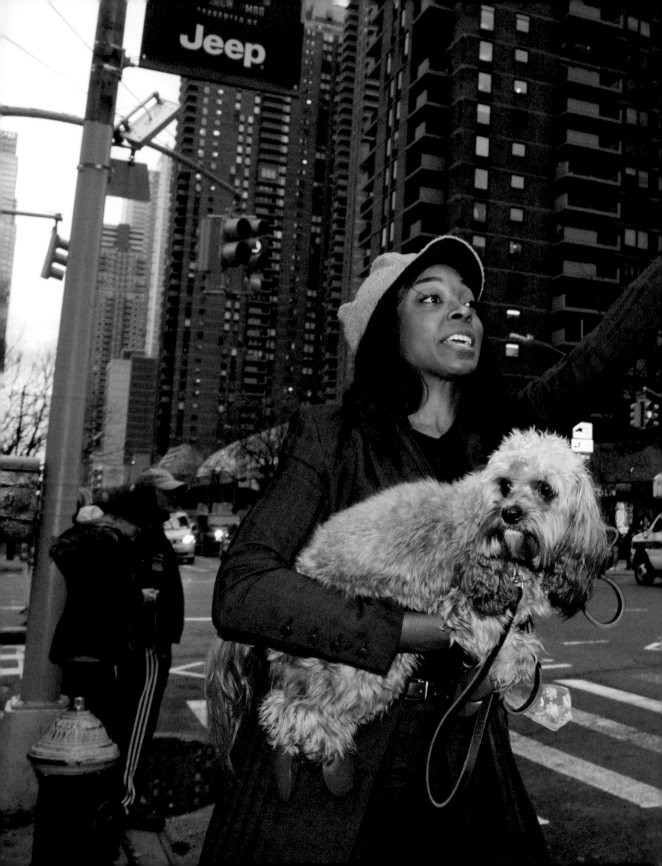

COOKIE AND CHAOS & NICOLE AND GEORGE

MOTT HAVEN, THE BRONX

Chaos was a birthday gift from Nicole's husband, George, because he was worried about her being able to get around on her own. He was her first dog, and she immediately fell in love. If anyone asked George why he chose a pit bull, the answer was, essentially, why not? He'd known pit bulls his entire life.

"Because of my back injury I was depressed and in a lot of pain," Nicole says. "My doctor wanted me to get out and walk. With no reason to do so, my husband got me Chaos." Of course, he knew exactly what he was doing. Nicole was no longer alone when he was working, and her walks with Chaos brought her to see their local park in a new way. She began an advocacy group for responsible dog owners, setting up information tables outside the community dog run, which at the time was just a small square of park surrounded by a hastily constructed fence. She met new people. She found Cookie and brought her home.

St. Mary's Park is thirty-five acres of elevated parkland in the most densely populated part of the Bronx, but for years the facilities have been in disrepair. Now, thanks to advocacy by people like George and Nicole, there are plans for a major overhaul, including improvements for dog owners.

"I raised children," Nicole says. "And my children have had dogs, but Chaos was my first dog on my own. He was so smart and protective. I wasn't expecting that. I had to keep up with him and be the owner he deserved."

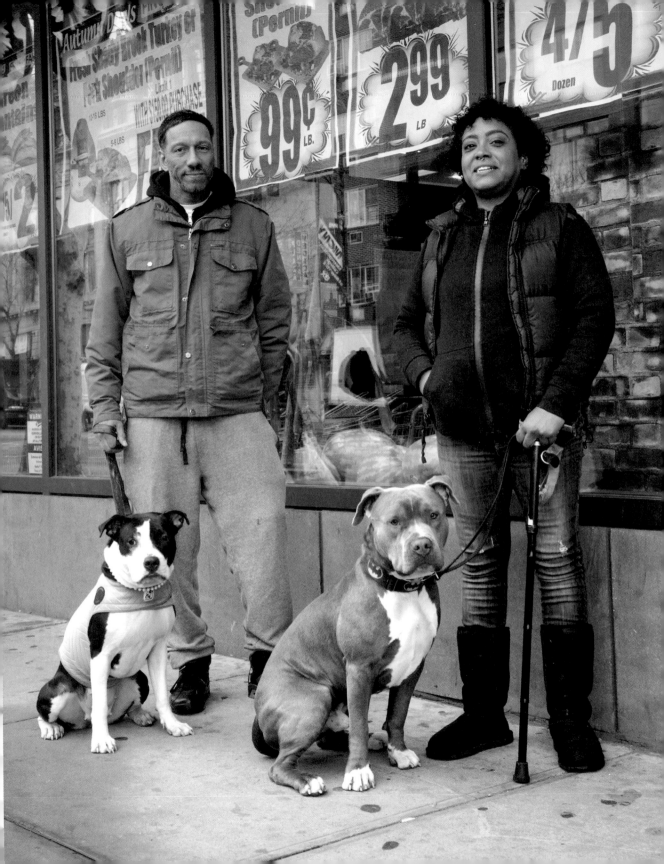

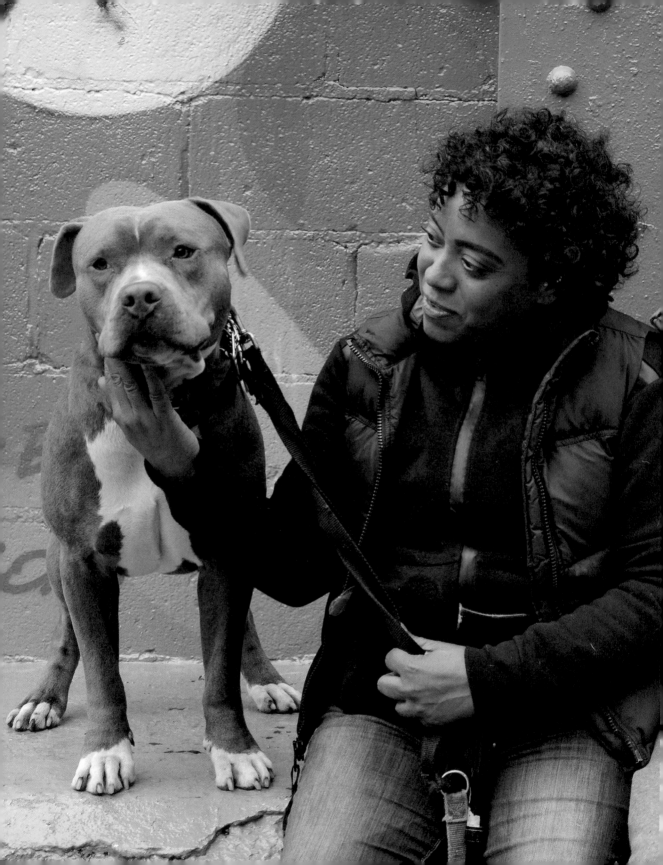

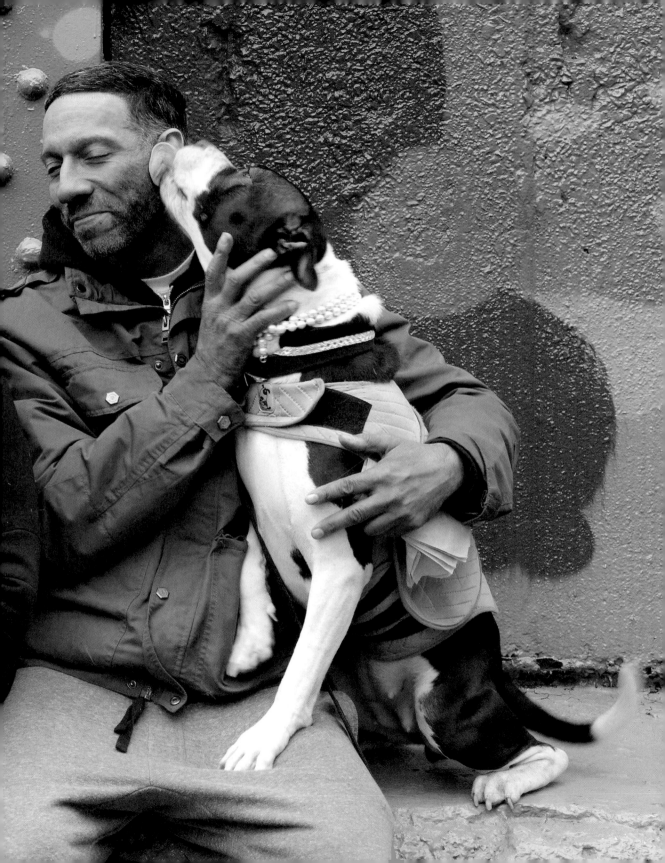

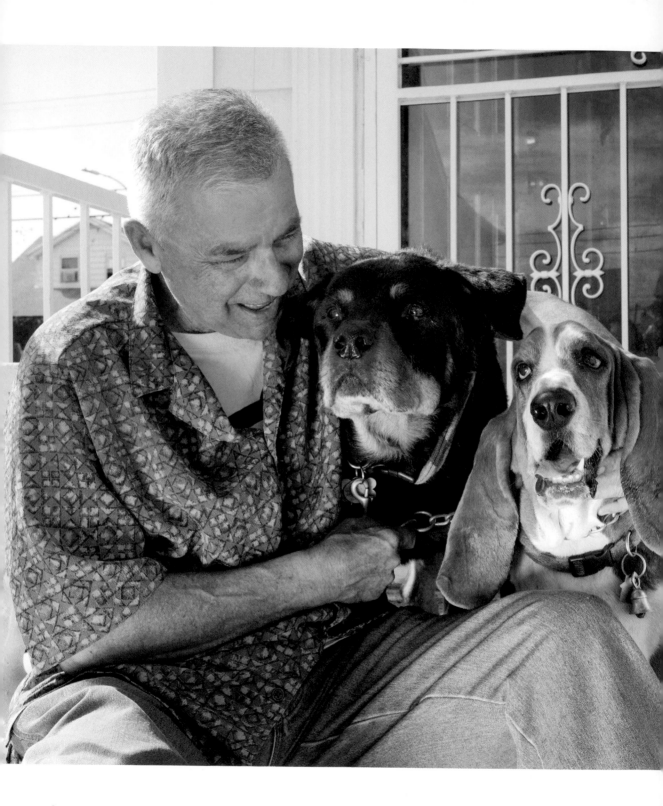

BEAR AND SNOOPY & FRANK

GERRITSEN BEACH, BROOKLYN

Gerritsen Beach is near the southernmost point of Brooklyn, and for that reason it wasn't developed as a residential neighborhood until the 1920s, when an investor began building bungalows to lure summer residents. Since they weren't intended for year-round tenancy, he built identical cottages, close together, with little or no yard space, since everyone would be at the beach. But people began to stay year-round. Now, the neighbors are in one another's business: the small yards are up against one another, and the front stoops have just a narrow driving path between them. It's the kind of neighborhood where everyone knows everyone, and everyone *really* knows Frank and his dogs.

Bear, the Rottweiler, was adopted from a city shelter, where his behavior was putting him at risk. That was a decade ago. Snoopy, the basset hound, is his younger brother. The three of them—Frank, Bear, and Snoopy—made the news a few years ago when Frank, a retired police officer, took his neighbor to small claims court to make him pay for vet bills incurred after the neighbor was caught on video slipping a sharpened bone through the fence. The court sided with Frank. If it sounds like a case on *The People's Court*, well,

the same two families appeared there, too, with a prior dispute.

But such conflicts aren't typical. Residents here are so devoted to their community that few of them left even during Hurricane Sandy, when virtually every home was flooded, some with as much as ten feet of water. Since then they have rebuilt, but one can still see the remnants of the reconstruction. Across the street, a cat is napping on the top rung of a ladder into an empty aboveground swimming pool. That's not officially its home, but it stays there anyway. Down the street, a neighbor reports that her dog has been getting visits from another wandering cat that knows to knock on the downstairs door, where the dog will let it in. At the end of the day, she comes home to find the pair snuggling. It is a beach community that way, even in winter, with boundaries casually and continually crossed, so word traveled fast when Bear passed away shortly after these photos were taken.

In a city of eight and a half million people, it might seem as if the passing of a single dog would go without notice. But we notice every one, even those whose names we never learned. Their presence, their routines, their barking and begging and kissing and playing, all become part of the rhythm of the city and it skips several beats when they are gone.

We never forget them.

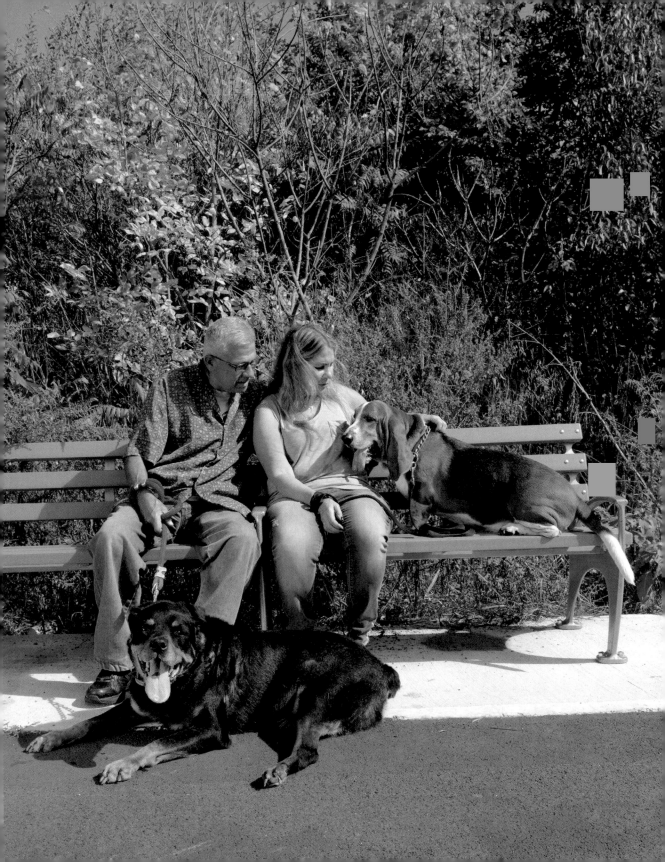

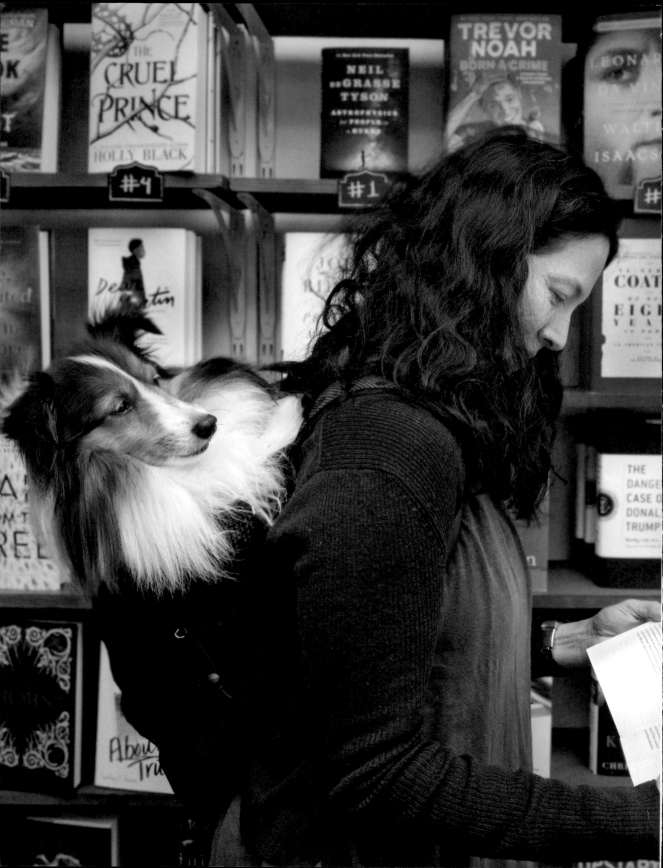

A CITY OF RESCUES

The dogs we love come from all sorts of places, just like the people who care for them, so it's no surprise that the canines featured in *City of Dogs* include a large number of rescues. In many cases, these dogs moved from the street directly into their new home. In others, they came from friends or neighbors. And many came from some of the hundreds of rescue organizations that operate in and around the City of New York. Here's an index of some of the organizations represented in these pages:

Animal Care Centers of NYC
nycacc.org
Charlie (Hunters Point), Alistair, Marlowe, Rudy, Julie, Bear

Animal Farm Foundation
animalfarmfoundation.org
The Rikers dogs

Animal Haven
animalhavenshelter.org
Mazzie (IAC)

ASPCA
aspca.org
Shanti, Toby, Gita

Badass Brooklyn Rescue
badassbrooklynanimalrescue.com
Whiskey and Karma

Bully Project
bullyproject.com
Ronnie (IAC)

Dog Tired Ranch
dogtiredranch.com
Coco and Chanel

Galgos del Sol
galgosdelsol.org
Baker

Guiding Eyes for the Blind
guidingeyes.org
Cecil, Junior

In Our Hands Rescue
inourhandsrescue.org
Sadie

Muddy Paws Rescue NYC
muddypawsrescue.org
Cricket

Humane Society of Westchester
humanesocietyofwestchester.org
Monkey

North Shore Animal League
animalleague.org
Oz, Shadow (with Shaun and Nora), Matilda

Stray from the Heart
strayfromtheheart.org
Rocket, Freya

Tails of Love Animal Rescue, Inc.
tailsofloverescue.org
Monet's dogs

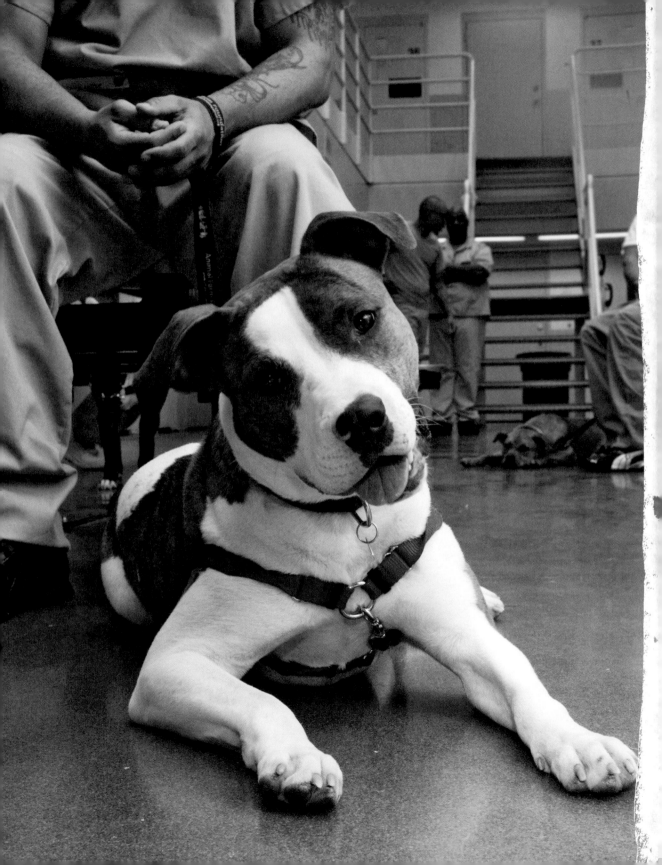